Nikon DSLR

Nikon DSLR

The Ultimate Photographer's Guide

Jim White and Tony Sweet

ELSEVIER

AMSTERDAM · BOSTON · HEIDELBERG · LONDON · NEW YORK · OXFORD
PARIS · SAN DIEGO · SAN FRANCISCO · SINGAPORE · SYDNEY · TOKYO

Focal Press is an imprint of Elsevier

Focal
Press

Focal Press is an imprint of Elsevier
The Boulevard, Langford Lane, Kidlington, Oxford OX5 1GB, UK
30 Corporate Drive, Suite 400, Burlington, MA 01803, USA

First edition 2010

British Library Cataloguing in Publication Data
White, Jim.
 Nikon DSLR : the ultimate photographer's guide. -- (Digital
 workflow)
 1. Nikon digital cameras. 2. Single-lens reflex cameras.
 3. Photography--Digital techniques--Amateurs' manuals.
 I. Title II. Series III. Sweet, Tony, 1949-
 771.3'3-dc22

Library of Congress Control Number: 2009930340

ISBN: 978-0-240-52122-0

For information on all Focal Press publications
visit our website at focalpress.com

Printed and bound in Canada

09 10 12 11 10 9 8 7 6 5 4 3 2 1

CONTENTS

CONTENTS

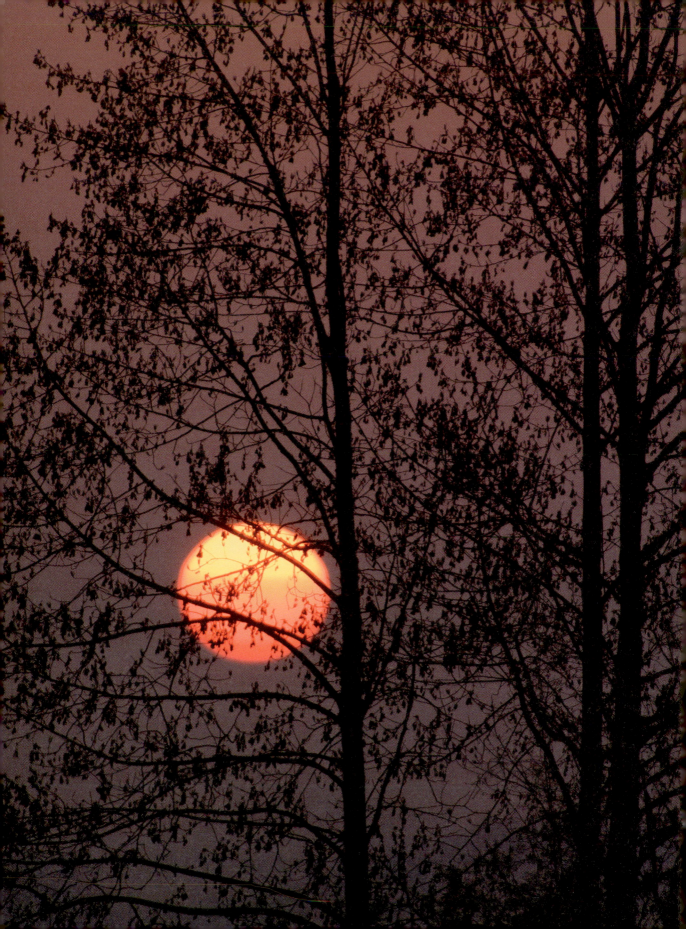

The Basics

The Exposure Triangle

The very fact that you have purchased this book means you plan to take your photography beyond the casual point and shoot stage. Although this book isn't designed to be an introductory course in photography, it is necessary to understand some important basic concepts to fully take advantage of your Nikon Digital SLR camera. To fully understand and utilize the creative power of these incredible cameras, you need to understand the relationship of aperture, shutter speed, and ISO, or what we will call the 'exposure triangle.' The basic rule to remember is that all three factors control your exposure: change any one variable and one or both of the other two must be changed as well. Understanding this relationship will allow you to move beyond making technically correct photographs to capturing really great images.

Aperture

The aperture is an adjustable opening in the lens of a camera. Somewhat like the pupil of our eye, the aperture adjusts to allow more or less light to enter the lens and reach the sensor. The size of the aperture is controlled via an adjustable diaphragm that opens or closes to allow more or less light to enter. On a standard camera lens, we measure in units called 'stops.' Each f/stop represents either double or half the

amount of light, depending on whether the lens aperture is opened or closed. The inverse relationship between the f/stop number and the amount of light entering the lens is confusing to many novices. As the aperture is 'stopped down,' the numerical f/stop value increases and as the lens is 'opened up,' the numerical f/stop value decreases. We would classify a 'fast' lens as one with a maximum aperture (minimum f/stop number) of, say, f/1.4 or f/2.8 for example. Typically the same lens would have a minimum aperture (maximum f/stop value) of f/16 or f/22. Remember, as you open up the aperture by one stop you are allowing twice the amount of light to enter the lens, and as you close down one stop you are reducing by half the amount of light reaching the lens. You can see in the examples below the effects of one-stop difference either way.

Each of the f/stop settings below represents a one-stop difference in aperture. As the f/stop numerical value increases, the amount of light decreases. Depending on which way the aperture is adjusted, each f/stop setting either halves or doubles the amount of light entering the lens and reaching the sensor.

f/1.4 f/2.8 f/4 f/5.6 f/8 f/11 f/16 f/22 f/32

Shutter Speed

Shutter speed refers to the amount of time the shutter remains open and allows light to enter and pass through the lens and strike the sensor. Shutter speed is measured in seconds and usually fractions of a second. You will often see 1/125 or 1/1000 as typically used shutter speeds for daylight photography, while 1/60 or even 1/30 is commonly used with flash or studio portrait photography. Many landscape photographers often employ shutter speeds involving several seconds.

As with the aperture, shutter speed is measured in units called 'stops.' Increasing the shutter speed by one stop decreases the amount of time light is allowed to strike the sensor by half. Conversely, decreasing the shutter speed by one stop allows twice as much time for the shutter to remain open allowing light to enter and strike the digital sensor. Obviously increasing or decreasing the shutter speed without making a corresponding adjustment to the shutter speed or ISO will result in an over- or underexposure of an image. (Figures 1.2, 1.3 and 1.4)

Figure 1.2

Figure 1.3

Figure 1.4

In the same way that different aperture settings affect the look and feel of a particular image, different shutter speeds can also produce various affects on the way a photograph is interpreted. A really fast shutter speed can literally 'freeze' action, such as a formula one car or even a bolt of lightning, while 'dragging the shutter' or intentionally shooting at a slower shutter speed can invoke a feeling of motion with the very same subjects. In this way aperture and shutter speed can be adjusted for a specific desired artistic affect.

Figures 1.5 and 1.6 are photographs of the very same subject; yet notice how different the images are due to the different shutter speeds.

Each of the values below represent a one-stop difference in shutter speed. As with aperture, depending on the direction we move, with each change in shutter speed we either halve or double the amount of light entering the lens and reaching the sensor.

1/15 1/30 1/60 1/125 1/250 1/500 1/1000 1/2000 1/40,000

Aperture and Depth of Field

Learning to understand and use the relationship between aperture and depth of field is probably the single most important creative tool available to you as a photographer. Using the Program mode, or Full Auto mode, on your Nikon Digital SLR will almost always yield a technically correct photograph, but often the aperture chosen by the camera is counter-intuitive to the actual intent of you, the photographer, as an artist.

The two factors that determine depth of field are aperture and the focal length of the lens. As we stop down the lens aperture we increase the depth of field, and as the focal length of the lens increases, the depth of field becomes smaller. In other words, a 16 mm lens at f/22 has a larger depth of field than a 400 mm lens at f/22.

Notice in Figures 1.7, 1.8, 1.9 and 10 how the very same image can be captured, presented, and interpreted in four totally different ways.

In Figure 1.7, notice how the object in the foreground is obviously the main subject, as the rest of the image is totally

Figure 1.5

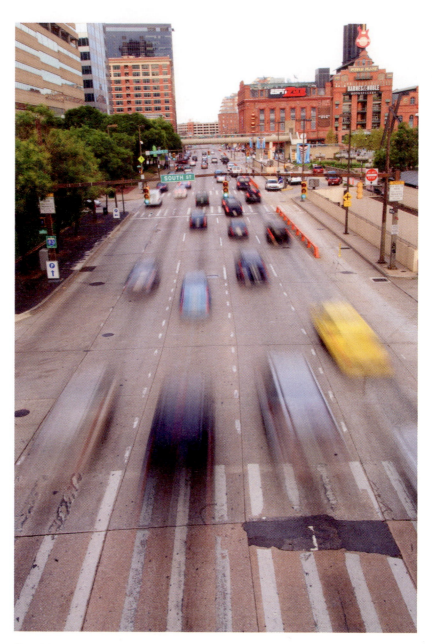

Figure 1.6

Figure 1.7

Figure 1.8

Figure 1.9

Figure 1.10

blurred and actually becomes a nice pleasing background. In Figures 1.9 and 1.10, as the background becomes more distinct, the object in the foreground becomes less of a subject, and more a part of the background.

The basic rule of thumb to remember is that as the aperture is stopped down (the f/stop numerical value increases), the depth of field increases. Conversely, as the aperture is increased (f/stop numerical value decreases), the depth of field becomes shallower. It is important to remember this inverse relationship between f/stop value and the amount of light the aperture allows through the lens.

The obvious implication for you as a photographer is that a wide-open aperture will place emphasis on the object or objects in focus, while rendering the out of focus areas of the image as part of the background. When the aperture is stopped down all the way, all or nearly all of the subject area of the image will be in focus. This means that the very same subject matter can be rendered in a totally different manner by merely adjusting the f/stop settings on our camera. Learning this relationship allows you to gain creative control of the imaging process.

Reciprocity

The rule of reciprocity means that for any shutter/aperture combination producing a correct exposure, we can adjust the shutter one or more stops, and the aperture correspondingly one or more stops, and arrive at a correct exposure. This means that as we increase or decrease the shutter speed, we need to increase or decrease the amount of light allowed through the lens and shutter to produce a correct exposure. In this equation it is assumed the ISO remains constant. In the chart below, assuming an aperture of f/8 and a shutter speed of 1/250 gives a proper exposure; any combination to the left or right of f/8 will yield a correct exposure as well. This rule holds correct for situations where the light is constant, such as a daylight scene.

f/32	f/22	f/16	f/11	f/8	f/5.6	f/4	f/2.8	f/1.4
1/15	1/30	1/60	1/125	1/250	1/500	1/1000	1/2000	1/40,000

Notice how each of the following images renders a correct exposure.

Figure 1.11 1/1250th second @ f/2.8

Figure 1.12 1/1000th second @ f/3.5

Figure 1.13 1/400th second @ f/5.6

Figure 1.14 1/250th second @ f/8

Figure 1.15 1/100th second @ f/11

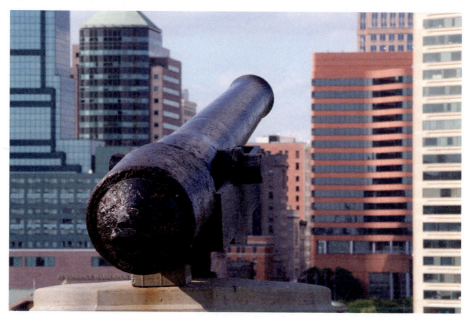

Figure 1.16 1/60th second @ f/16

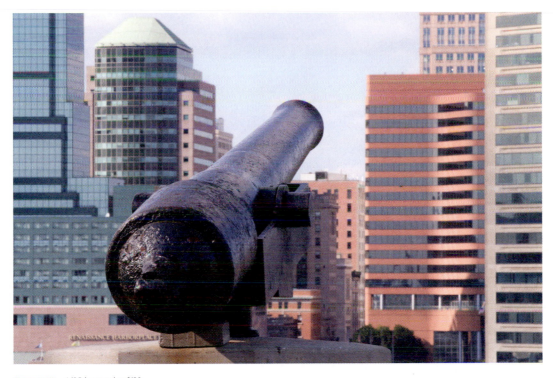

Figure 1.17 1/25th second @ f/22

ISO

ISO (formerly ASA) is a numerical value representing the sensitivity of your digital sensor. ISO traditionally referred to the sensitivity of film, so often digital cameras tend to refer to ISO equivalents. The higher the ISO setting the more light sensitive the sensor is, or less light is required to get a correct exposure. Knowing this would lead us to ask why we wouldn't opt for the higher ISO settings so as to maximize shutter speed and sharpness. The hard fact is that it is a trade-off: the higher the ISO the more digital 'noise' produced and the longer it takes the camera to process the image and write it to the memory card. Just as increasing the ISO makes the digital sensor more sensitive to light, it also increases the sensitivity to digital noise. The newer generation of Nikon Digital SLR cameras have amazingly low noise, even at higher ISO settings, but images shot at ISO 100 are still noticeably cleaner,

especially when you zoom in close and crop. Compare Figures 1.7 and 1.8. These are crops of the same image shot at ISO 100 and ISO 3200. Notice the difference in digital noise levels.

Some photographers use this effect for creative purposes, the same way that grain was employed during the heyday of film cameras, but most photographers will opt for lower ISO settings when given the option.

Each ISO value below represents a one-stop difference. With each increase or decrease in ISO value, we either double or halve the amount of light required to get a proper exposure.

50 100 200 400 800 1600 3200

Remember, as any one aspect of the exposure triangle is changed for a given situation, one or both of the other two must be adjusted to maintain a correct exposure value.

Resolution and Sensor Size

Resolution basically describes the ability of a particular capture device to 'resolve' information captured by the digital sensor. Popular thinking is that more pixels is 'more better,' but this is not necessarily the case. In actuality, the smaller the sensor size of a digital camera, the smaller the pixel size. Smaller pixels gather and resolve less light and produce more digital noise during processing. In addition, placing more pixels in a smaller area means the space between adjacent pixels is reduced, which produces even more digital noise. Consequently, a 10-megapixel point and shoot camera and a 10-megapixel digital SLR are far from equal in resolution. The digital SLR will always produce a smoother image with a better *dynamic range* than a point and shoot camera.

Notice the difference in Figures 1.18 and 1.19. These are details at 100% from the same image, the first one shot with an SLR and the second with a point and shoot camera, both 8 megapixel. Notice the difference in sharpness and resolution and how much more digital noise is produced by the smaller sensor.

One of the most controversial areas of digital photography revolves around sensor size, in particular with regards to full-frame sensors. The APS sized sensors, which are smaller than full-frame, produce what is termed a 'crop factor,' or a

Figure 1.18

Figure 1.19

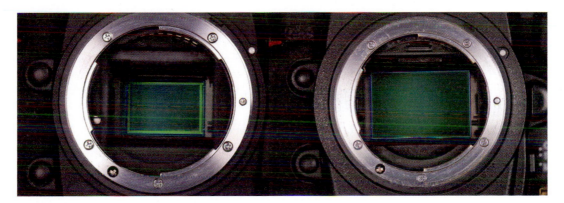

Figure 1.20

magnification factor of 1.5×. Because the sensor is less than full-frame, each lens produces a telephoto effect. In all Nikon Digital SLRs with the exception of the D3 and the D700, a 100 mm lens has the focal length equivalent of a 150 mm lens. Figure 1.20 shows the two sensor sizes used by Nikon Digital SLR cameras.

For most people, the lack of a full-frame sensor isn't a problem. The viewfinder still reflects the capture area so for all practical purposes what you see is what you get. For professional photographers, in particular sports shooters, a high-resolution

full-frame sensor with its wider capture area does provide some advantages, such as the ability to crop several usable images from one capture.

For most of us, the practical implication is that the effective focal length of our lenses is changed. Wide-angle lenses become less wide angle and standard to medium telephotos become even more telephoto. Obviously this can be an advantage or a problem, depending on what you are shooting and where you are standing. When all else fails just pick up your feet and move. Some photographers still say the best zoom is your own two feet!

Getting Started

So now you have your new camera and you are ready to get started. Hopefully you read at least some of the instructions that came with your camera but we will cover some basics to get you up and running for those who can't wait.

Figure 1.21

Figure 1.22

Figure 1.23

- Start with inserting the battery. Nikon cameras come from the factory with a partial charge but you should charge the battery fully in the charger provided prior to using the camera. Today's batteries provide hours of continuous use but by the time you see a low battery symbol on the LCD it's too late. This will usually happen at the worst possible time so it's good to purchase at least one or more spare batteries to keep in your camera bag. Drop the battery into the battery compartment with the contacts down (it will only go in the right way fortunately) and close the compartment door.
- Attach the camera lens by aligning the white dots and rotating the lens counter-clockwise; you will lock it into place. Never force a lens onto a camera. It should always fit and turn smoothly.
- Set the focus switch on the lens to M/A for auto focus and manual focusing capability.

Figure 1.24

Figure 1.25

Figure 1.26

- On the D40, D40X, D60, and the D80, insert a Secure Digital (SD) card into the memory card slot. On the D300 and D3 insert a Compact Flash (CF) card.
- Turn the camera's power switch to the 'On' position.
- In the camera's menu, under the Setup Menu, choose the format memory card option and format the new card. You should always format a new memory card and use this option to prepare the card for use each time rather than just erase the images from the card via the camera or your computer. This will help prevent file corruption and subsequent loss of your precious images.
- To get started, set the camera mode to Full Auto (Green Camera) or the P mode. This way the camera will make sure you get a correct exposure by deciding the aperture, shutter speed, white balance, and ISO based on the existing light.

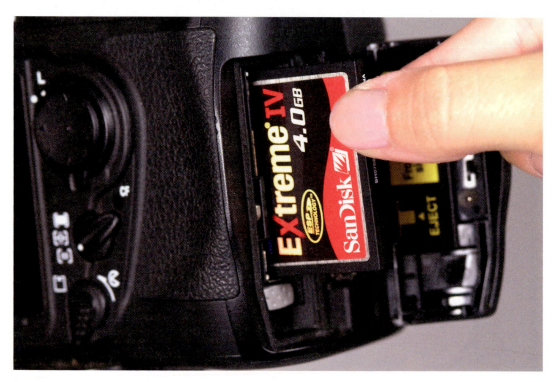

Figure 1.27

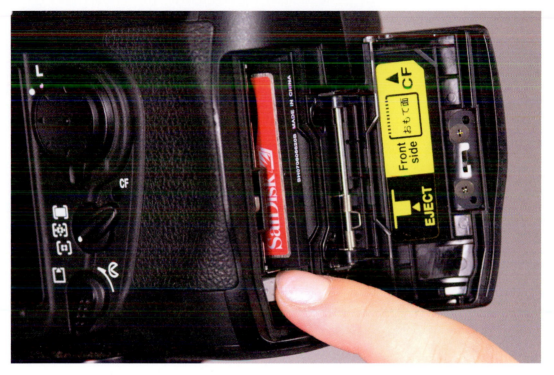

Figure 1.28

- Through the camera's viewfinder, frame your shot by moving the camera, changing your position, or adjusting the zoom lens if you have one.
- Lightly press the shutter release to lock the exposure and focus, and then press it the rest of the way to complete the image capture.
- You can check the results in the LCD. Although this is not necessarily the most accurate way to assess the exposure, it will at least let you know if you are in the ballpark. At this point the image has been written to and saved on the memory card.

Setting Up Your Workflow

A Successful Workflow

Developing a solid workflow means having control of the imaging process from capture all the way to the final output, regardless of whether the image will be printed, used on screen, or on a web page. A successful workflow also means taking the 'flow' part of the word seriously. You must develop an orderly approach to processing your digital files that will allow optimum image quality with as little wasted time as possible. If you frequent any of the photography publications you are bombarded with articles about this or that particular photographer and his or her particular equipment and workflow. While it never hurts to see what others are doing, keep in mind that your workflow will ultimately be a very individual thing. Get the tools you need but don't switch to a particular software program just because someone else is using it. Make adjustments to your workflow habits based on need. Since the beginning of your workflow starts with image capture we can start with some of the choices we make in-camera.

Color Space

Nikon Digital SLRs offer a choice of either sRGB or Adobe RGB color spaces for image capture. Either color space is capable of producing excellent output, and which one you choose should be based on the

intended use of your image. Is it for publication in a magazine or book? Do you plan on processing and printing your own images? Are you planning to shoot JPEGs and turn them over to a print agency for processing and printing? Your answer will dictate your choice of color space.

Adobe RGB (1998) has a larger *color gamut,* meaning more colors can be displayed within the color space. For those planning to edit and print their own digital files, many photographers believe Adobe RGB is a better color space; but this is only a personal preference and not a caveat. More recently, some photographers have adapted the ProPhoto RGB color space as it provides an even larger color gamut than Adobe RGB.

The sRGB color space was developed cooperatively by Hewlett Packard and Microsoft to provide a color standard for monitors, printers, and the Internet, so consequently most web browsers are designed to best display images with this color space. In actuality most commercial and desktop printers are sRGB driven devices and many print agencies specify the sRGB color space as the commercial printers are calibrated for it. If you plan to shoot mainly for web output, or you use an outside agency specifying sRGB to print your work, shooting in sRGB mode can save you a great deal of time later as you won't be faced with converting a large batch of images. You can always convert to another profile later but the whole idea of workflow is to avoid putting extra steps in the process.

JPEG or RAW

All Nikon Digital SLR cameras offer the option of capturing in either JPEG or RAW format. Which file format you choose depends on what you are shooting and the intended end use.

The JPEG file uses a compression file format, which results in a much smaller file size but at the expense of image quality. Each time a JPEG file is opened, edited, and re-saved, it undergoes another round of compression, which degrades image quality. After several such operations there is a noticeable loss of image quality, usually in the form of what are called JPEG 'artifacts.' One way to work around this is to save the original JPEG as an 8-bit TIFF file and use this as your master file. In this way the only loss suffered is from the initial, in-camera compression.

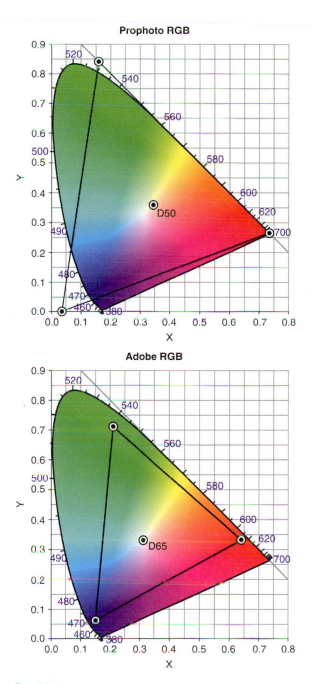

Figure 2.2

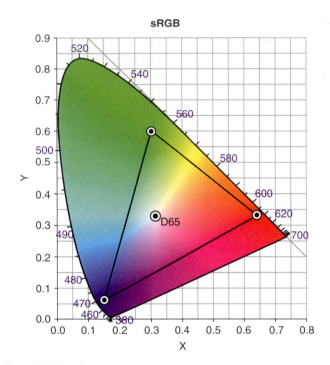

Figure 2.2 (Continued)

JPEGs are 8-bit files, which contain 256 shades of color in each of the three color channels. By contrast, a 16-bit TIFF file created from a RAW file contains over 65,000 shades of color in each color channel. The practical implication for us as photographers is that with a RAW file, and the resulting 16-bit TIFF file, we have more information to work and edit with, which translates into better overall image quality. Figures 2.3 and 2.4 illustrate the number of colors in an 8-bit and a 16-bit file, respectively.

In its favor, the RAW format provides huge latitude for adjustment after the fact. You can adjust up to two stops of exposure, plus or minus, after the fact, and white balance can be adjusted afterwards as well. Sharpness, contrast, and noise levels can also be adjusted when RAW processing. From these digital negatives you can produce large 16-bit TIFF files, containing much more resolution and color information than that found in the JPEG format.

Figure 2.3

Figure 2.4

JPEG has its own legion of fans for several reasons, but size and ease of use are primary. Properly exposed JPEGs in the right hands can produce beautiful output for print and screen. The smaller file size makes batch processing a large number of JPEGs much less time-consuming as well.

A large RAW file is somewhat overkill when you are shooting a small piece of jewelry for eBay, but on the other hand if you have your camera set to capture a small or medium JPEG and you grab a priceless shot of your child scoring the winning goal in a soccer match you will be sorely limited by the small resolution of the JPEG format. Another consideration is the quantity of images you plan to shoot in a given session. Most landscape and fine art photographers will choose RAW for the potential file size and editing latitude it allows for later. In today's digital world, for many wedding photographers to shoot anywhere from 800 to 1500 images isn't unusual. Consequently most wedding

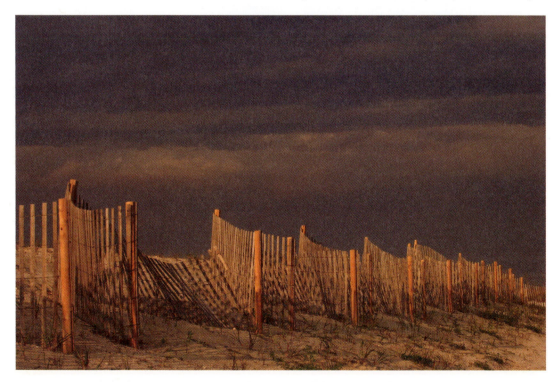

Figure 2.5 Images with large dynamic range and complicated color gradation benefit from editing in 16-bit mode.

photographers shoot in JPEG mode to minimize post processing and avoid hours of tweaking in front of the computer screen.

Nikon Digital SLRs currently allow the user to select RAW *plus* JPEG as an option. This gives you the best of both formats, but plan on carrying more memory cards that are now so inexpensive that it is no longer a real issue.

The bottom line is to consider all relevant factors involved in your workflow when deciding on an image format. What is the intended use for these images? What is the largest resolution (image size) I will need? How much time will be involved in post processing?

Transferring Images to Your Computer

Having worked many years in a camera shop I can safely say that most folks just plug their camera into the computer and use whatever program automatically launches to download images.

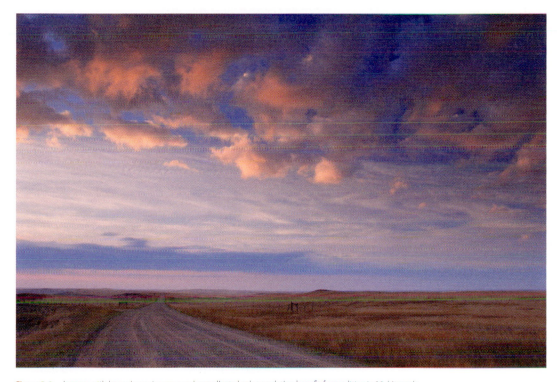

Figure 2.6 Images with large dynamic range and complicated color gradation benefit from editing in 16-bit mode.

Figure 2.7 The JPEG format is quite well suited for the wedding photographer who must shoot and process hundreds or thousands of images.

This certainly gets the job done, but usually at a snail's pace and at the expense of draining the charge on your camera's battery. A better option is a dedicated Firewire or USB 2.0 card reader. These are inexpensive, much faster, and use the computer to power the device. The card will typically show up as another drive on the computer and you can choose an application such as Nikon Capture NX to download images, or just drag and drop to the desktop or the desired folder.

Storage

This brings us to the issue of storing your images. For any important projects you should first burn a CD or DVD of your session before proceeding further. This will act as your digital negatives and provide a back-up for the unexpected, which can

and eventually will happen. Most photographers keep external drives for back-ups of their important image files and so should you: 100, 250, and 500 gigabyte, and even terabyte size external drives are readily available and relatively inexpensive as of this writing. Some photographers even keep an extra drive off site so that in the event of a fire or other natural disaster they have all bases covered.

The other factor to consider is to avoid filling up your primary hard drive with all of those pictures. Image editing programs tend to need a lot of memory and a great deal of extra working space, also known as 'scratch disk' space, to perform optimally so loading your hard drive up with all those image files can definitely affect performance. Whatever methods you decide to use, do not depend on your computer's main hard drive as your only storage medium. Hard drives can and will fail, and you risk the loss of your entire precious image library if all of your eggs are in one basket so to speak.

We prefer to shoot RAW + JPEG High so we have two high-quality versions of each image. This requires more storage but, as mentioned previously, large, high-quality memory cards are cheaper than ever so that is no longer an issue. The JPEGs can be separated, rendered and previewed quickly, making it a simple matter to cull out the keepers and the maybes and eliminate the rest. File names will be the same except for the file extensions (NEF and JPG) so it is easy to separate out any RAW files we wish to keep as well.

We keep the images on the primary hard drive in order to post process and then they are transferred to an external drive for storage. The finished files are stored in 16-bit TIFF format as 'Master Files'. All other uses for the images are rendered from that master file and saved as new files. The master file is always left intact.

Another word is in order here regarding the use of CDs and DVDs as storage media. The jury is still out on just how long a standard CD or DVD will last. There is some evidence that deterioration occurs much more quickly than previously thought; some sources estimate only 5–10 years. That being said, this does bolster the argument for using the gold archival CDs and DVDs such as those made by Delkin. The company claims up to 300

years or more of storage, so if you are interested in true archival storage of your work you should consider this option.

Color Management

Color managing your digital workflow is essential to producing optimal image quality. It isn't necessary to fully understand or become an expert in color management in order to implement the basic essentials in your workflow; just learning and implementing a few basic principles is enough to ensure success.

The first step in a color-managed workflow is a properly profiled monitor. Whether you use an LCD or CRT, it is absolutely essential that you work on a properly calibrated and profiled monitor. If you plan to make any adjustments to your images, and

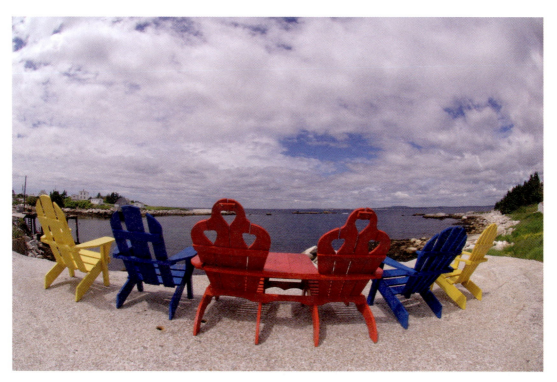

Figure 2.8 Incorporating and practicing color management in your workflow will assure that what you see on your monitor will be what you print or share with others.

particularly if you have designs on printing your own images, working on a monitor that has not been properly profiled is somewhat akin to throwing a dice when you send a print job to the printer. Your image editing program has no idea how your monitor sees color so a best guess is what you get. Sometimes this works OK at best, but for the most part you get print output that varies from a bit off to unusable.

There are several products on the market for color management and monitor profiling. Any one of them is better than nothing. Good quality, relatively inexpensive calibration devices are available from companies such as X-Rite, Colorvision, and Pantone that make this an easy part of the workflow process.

If you plan to do your own printing, which most beginning and intermediate photographers do aspire to, learning how to proof and print using ICC profiles will be worth the time investment on your part. Good quality ICC profiles can be downloaded from the web sites of most paper manufacturers. For a small fee, you can have custom profiles made for your printer and favorite paper, or you can purchase profile-making equipment from the same sources that manufacture the monitor calibration devices.

Corey Hiltz

Corey is a professional photographer who works out of the Washington DC area. He does commercial and stock work in addition to teaching and conducting nature photography field workshops. We asked Corey to share his Nikon experience with us, and also share some of his digital workflow techniques.

'My first experience with an SLR camera was in 2000 when I was traveling around the United States for nine months. I was just taking snapshots, but I learned plenty about all aspects of photography. I enjoyed the SLR's greater control and functionality compared with my point and shoot camera. I started off shooting negative film and it wasn't until I switched to slides that I really learned about exposure. It turned out I was way off the mark in correctly figuring the exposure, but I didn't realize this because of the wide latitude of negative film. I quickly found that slide film wasn't so forgiving!

Figure 2.9

Figure 2.10

Figure 2.11

For the most part I am a self-taught photographer. I started out by reading and rereading *John Shaw's Nature Photography Field Guide*. It covered everything from exposure to equipment to composition. Exactly what I needed to get started. Nature photography was a natural fit because I enjoy being outdoors— hiking and exploring. As I looked to improve my photography I took knowledge anywhere I could find it. I joined a camera club, attended a couple of weekend seminars, took a darkroom class… but found I learned best from getting out and taking pictures. I began by working hard to master the fundamentals: proper exposure, subject in focus and good light. I photographed subjects ranging from close-ups to landscapes. Going to as many places and photographing as much as I could was important.

The next important step for me was learning to edit. While reviewing my slides I became a ruthless editor and tossed out

everything substandard. I still think of this today when editing digital photos. Not sharp? Overexposed? Underexposed? It's out of here! My goal is to never keep the 'almosts' (almost sharp, almost well exposed, almost a good composition) because in the end I have a much stronger library of images. Although we have more latitude today adjusting RAW files, one still must start with a good picture to make it a great picture. Pay attention to the 'almosts' and remember why you throw them away.

After a couple years with the N2020 I moved up to the Nikon F100 to take advantage of features such as depth of field preview and expanded metering options. I used the F100 through the rest of my film shooting days and kept the N2020 as a back-up. As I further immersed myself into nature photography, the photographs and techniques of Freeman Patterson and Tony Sweet had a major influence on me. I admired the artistic nature with which they both approached their subjects. Their expert use of visual design challenged me to continue to improve my photography skills. I looked for new approaches to using elements such as color, line, shape, texture and pattern. I was also introduced to the techniques of multiple exposures and montages. Talk about a new way to see things! I was hooked and had a great time experimenting and practicing these techniques. When selecting subjects and compositions I strived to improve my ability to use elements of visual design, which has been reflected in the higher caliber of images I create.

While striving to improve my skills as a photographer, I was also working toward building it into a business. I researched the business side of being a freelance photographer and explored the business opportunities in the nature photography field. I read books and interviewed professional photographers to find out how they ran their businesses. As I built up my business I have done commercial photography in addition to nature photography. In the realm of commercial photography I've photographed architecture, events, people and products. One of the first things I learned about the nature photography market is you must diversify. The odds weren't in my favor to make a living just selling prints or only shooting stock. As a result, I have worked to build my business in a number of areas. I sell fine art prints, I have my photos represented by stock agencies, I teach workshops, I license my photos to publishers

and I do assignments. My greatest passion of all of these areas is teaching. I enjoy sharing my knowledge to help others become better photographers. I began by teaching classes through local community colleges and adult education programs. As I gained experience I expanded my teaching to local workshops in the Washington DC area. I continue my local teaching, but now also lead workshops in other areas of the United States and abroad. The market continues to change and one has to adapt to stay competitive and run a successful business.

When Nikon introduced the D2x I decided to switch to digital. However, the D2x was a hot item and I used a D70 briefly (I needed a digital SLR for an assignment) until I could get a D2x. At that point I felt the megapixel capacity had reached a high enough quality level that I could stop shooting film. Another key feature of the D2x is its ability to do in-camera multiple

Figure 2.12

exposures. Being such a fan of this technique I would have felt limited if I was unable to do this in-camera. If this feature didn't exist it wouldn't have kept me from switching, but it sure made the decision easier. The D70 was my back-up camera for a while, but it's now been replaced by a D200. I also use the D200 when I want to be less conspicuous with my camera. For instance, while doing travel photography it attracts less attention if I'm walking around a city with the D200 instead of the D2x.

An efficient digital workflow is important for making the most of my time in front of the computer. I capture my photos in the RAW file format. I first download and rename my photos. My file names include the following information: my last name, the date the photo was taken and the file sequence number (the four digit number the camera uses to name the file). For example: Hilz_080417_7284.NEF. Including a last name or initials identifies who took the photo. The date lets me know when the photo was taken just by seeing the file name. Using the year-month-day sequence will keep my photos in chronological order in a folder. The four digits at the end give a unique identifier to photos taken that day. By renaming my files in this manner I avoid the possibility of having duplicate files names.'

Common Features of Nikon Digital SLR Cameras

Thoughtful Design

We had the opportunity to work with many different Nikon cameras during the writing of this book, and found that common body design and location of features made for a comfortable transition when going from one model to another. The huge advantage here is that if you choose to work with another camera in Nikon's line-up, many features will be instantly familiar. This is a real boon if and when you decide to move up to a more advanced model camera. You won't be starting all over again.

Camera Features

Power Switch

The power switch on all of Nikon's camera bodies is located on the top of the right-hand grip, and encircles the shutter release button.

The options are simply 'off' and 'on'. Models from the D80 and up will also illuminate the info display screen on top of the camera if you continue to move the switch to the right and hold the power switch. Being placed close to where your finger rests naturally is great for quickly grabbing your camera and

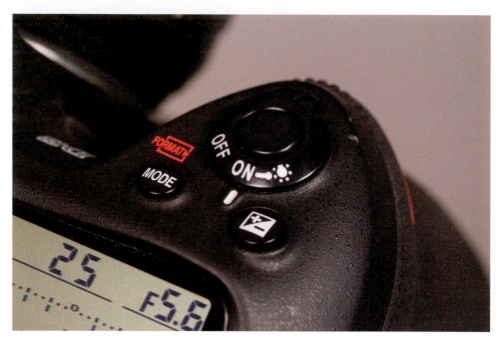

Figure 3.2

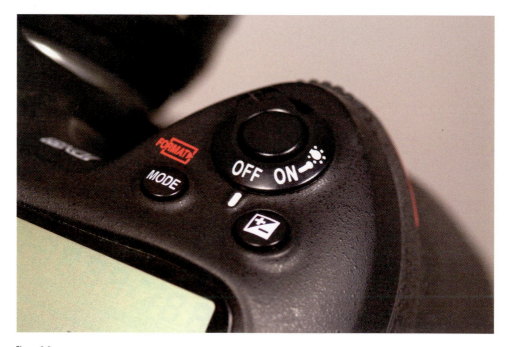

Figure 3.3

simultaneously turning it on, as well as illuminating the top data screen in low lighting without ever taking your hand away from the grip.

Shutter Release Button

The shutter button is conveniently located just above the handgrip, where your right index finger naturally rests.

Depressing the shutter button halfway will set the auto focus and displays your camera settings (and exposure display if in manual mode) both in the viewfinder and on the top control panel. Press all the way down to release the shutter.

Multi-Directional Rear Command Dial

This multi-functional hub controls a host of functions and consists of individual up/down, left/right, and center 'do it' buttons.

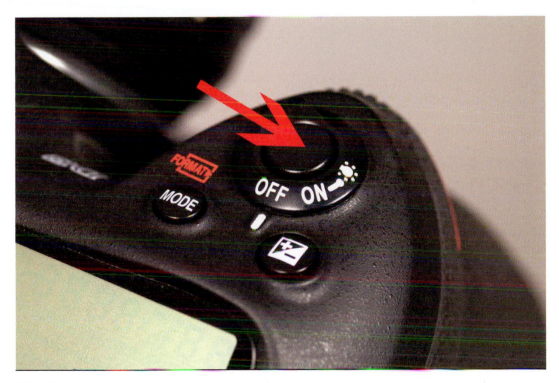

Figure 3.4

Figure 3.5

When in menu mode, the directional buttons allow you to navigate through and make changes in the camera menus.

In image playback mode, the horizontal buttons allow scrolling through images and the vertical buttons will change which image data is displayed, such as displaying a histogram metadata, or just the image itself.

The selector is also used to move and designate your focus points.

Main Command Dial

The main command dial is located on the top right side of the back of every Nikon camera. Although some functions vary on some models, it is universally used for changing shutter speed, exposure values, and flash mode.

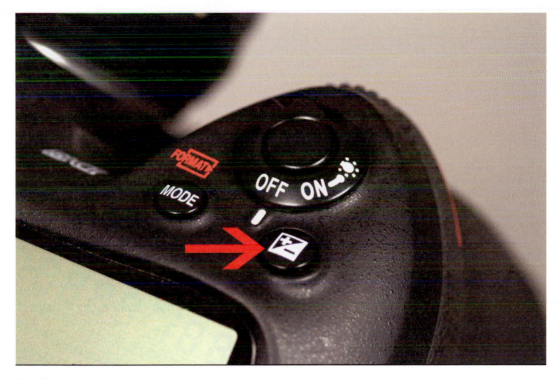

Figure 3.6

Exposure Compensation

Exposure compensation is controlled in the same way on all Nikons. Press and hold the $+/-$ button located just behind the on/off switch on the top right side of the camera while turning the main command dial to increase or decrease the EV value.

Positive values will result in brighter images, while negative values will make them darker. Remember, exposure compensation is not reset when the camera is turned off, so make sure the EV value is where you want it the next time you shoot!

Reviewing Images

Pressing the playback button will display images on the rear LCD screen on Nikon cameras. It is the top left button on the back of the camera and is marked by a triangle inside a square.

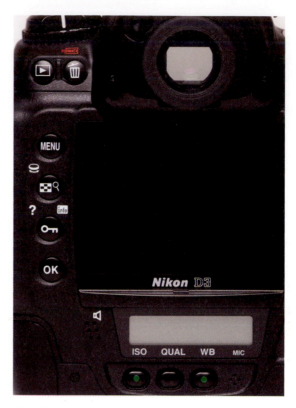

Figure 3.7

To scroll between single images, use the rear thumb selector's horizontal directional buttons. You can also view thumbnails for faster navigation by pressing the thumbnail/zoom out button once to view four thumbnails (Figure 3.6), and once again to view nine thumbnails at a time (Figure 3.7) (except D3—hold down the thumbnail/zoom button and move the main dial to the left to zoom out and to the right to zoom in on an image).

If you want to take a closer look, press the zoom in key to magnify an image.

Menus

Every Nikon includes the same main menus including the Playback Menu, Shooting Menu, Custom Setting Menu, Setup Menu, and Retouch Menu.

In the Retouch Menu, cropping, monochrome conversions, skylight and warm filters, and image overlays can be applied in-camera.

All models allow you to create a custom menu by selecting your most commonly used functions from all the menus, aptly named 'My Menu.' This saves a great deal of time by limiting the amount of flipping through menus to find what you need when you're shooting.

ISO

The ISO value controls the sensitivity of the digital sensor: the higher the numerical value, the more sensitivity to light. Higher ISO settings allow for faster shutter speeds in lower light. The inevitable trade-off is more digital noise and less accurate color balance.

You can select ISO 200-1600 in all models, with some models such as the D3 adjusting down to ISO100 and up to ISO 6400.

White Balance

In all Nikon cameras, there are pre-set white balance settings for incandescent, fluorescent, direct sunlight, flash, cloudy, and shade. Auto white balance is another option, which will adjust the white balance using color temperature measured by the image sensor. The ability to preset a custom white balance is also offered in all models.

Quality

You can choose to shoot in NEF(RAW) format, or JPEG small, medium and large. You can also shoot a combination of RAW and any one of the JPEG formats. We like to shoot RAW plus small JPEG. This gives you the best of both worlds: you have the large high-resolution version for editing and a small version, which will quickly load, in your browser for fast proofing.

Protect Images

When viewing your images in playback mode, you can press the protect key to prevent accidental erasure of any important images. Many scoff at this feature but it can really save you if you are shooting a job for pay. It is easier than you might think to mix

Figure 3.8

up images or memory cards and erase important files. Think of it as free insurance.

Erase Images

When you come across an image you have no desire to keep, press the delete key (marked by the Trashcan icon). You will then be asked to confirm your intentions by pressing the delete key one more time to erase, or to hit the playback key to cancel.

Focus Modes

S = Single-Servo Auto Focus

C = Continuous Servo Auto Focus

M = Manual Focus

AF Area Mode

Closest Subject

Dynamic Area

Single Area

Metering

Matrix/center/spot

Noise Reduction

On/Off

Image Optimization

Normal

Softer

Vivid

More vivid

Portrait

B&W

Custom (choose sharpening, tone compression, color mode, saturation, hue adjustment)

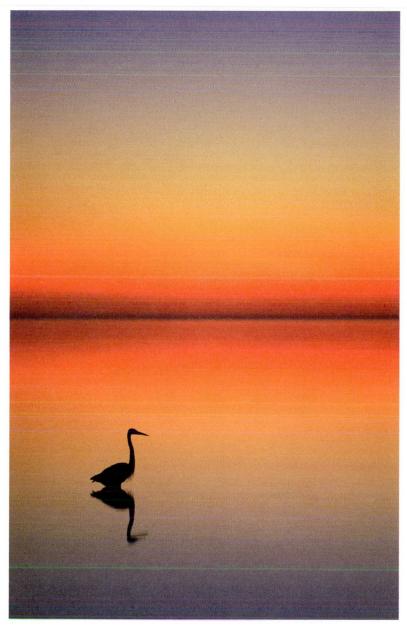

Figure 3.9

Nancy Rotenberg

Nancy Rotenberg is a freelance photographer, a writer, and an educator. Her images and editorial have appeared in magazines such as *Adirondack Life, Birds & Blooms, Canadian Camera, Country Gardens, National Geographic, Nature's Best, Peterson's Photographic* and *Outdoor Photographer.* Nancy's work has also been used by Hallmark, Red Oak, Reiman Publications, Renaissance and Sunrise Greeting Cards; as well as in calendars such as *Inner Reflections,* Nikon, Mitsubishi, Smith-Southwestern, Teldon and Willow Creek.

Nancy is the author of three books: *How To Photograph Close-ups In Nature, Capturing Nature's Intimate Landscapes* and her latest book, *Photography and The Creative Life.*

Nancy has been leading photography workshops and teaching for 12 years. Her goal as instructor is to encourage other photographers to create visual statements that go beyond documentation—to photograph intimately and with feeling. Nancy brings creative vision and enthusiasm for the natural world to her workshops and writings, and a passion for experiencing life with joy, heart and soul.

'Photography is a celebration for me. It is a celebration of what is beautiful in nature and in life. Photography is art for me. It is a verb, a way, and a state of being.

I want to learn techniques and then transcend them. My camera bodies are Nikon's D3 and Nikon's D300, and I use Nikon lenses, ranging from the 12–24 mm to the 200–400 mm. My favorite lens is Nikon's 200 mm macro lens. Although I love good tools, and great optics definitely make a difference, buying the latest and greatest is not a magic wand.

I believe that each one of us has what nobody else has or nobody else can purchase anywhere. We all have our unique light that arrives somewhere from the marrow and emanates from the heart. Creating has to do with your perception of the world and the light and passion that you bring to it. My goal for my own work and my mission for my students is to create images that wouldn't exist without that light. As we take the gifts of the universe when they are offered to us, we make something particular that wouldn't have existed without our presence—our consciousness—our light.

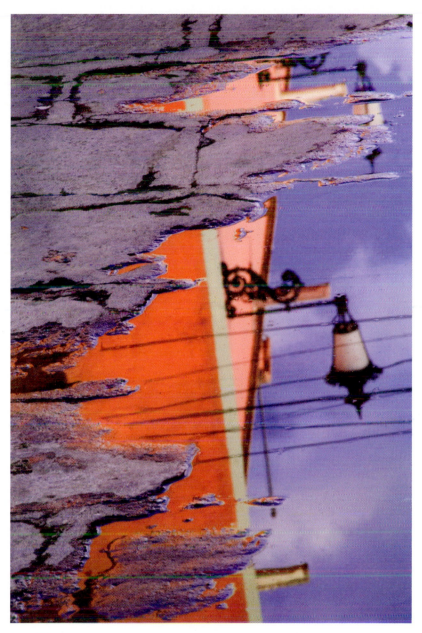

Figure 3.10

I like to develop a relationship with my subjects—to be aware of every nuance—to go beyond a handshake with them. When you see with mindfulness, when you start to pay attention, you begin to develop an intimacy with your subjects and you no longer walk sightless amongst the miracles and magic that are all around. One of my favorite quotes from R. D. Laing, 'The range of what we think and do is limited by what we fail to notice,' resonates with me as I travel on my creative journey. It tells me that no matter how much great equipment I have in my backpack, if I don't pay attention and enter the world with mindfulness, I will miss one of the most important features of seeing and living. I will miss moments and I will miss life.

I work hard at not getting caught up in final product and ego. 'Failing' is part of a creative process. If you're not failing every now and again, you're not moving—not growing. I remind myself frequently of Eleanor Roosevelt's famous comment: 'Nobody can make you feel inferior without your consent.' If you buy into the premise that photography is about comparing ourselves to others or about perfection, or if you photograph afraid to break any perceived rules, you might miss the opportunity to explore who you are and your own unfolding and your own need to create. When art is viewed only as a noun, and ego is tantamount to creativity, the process will create impoverished photographers, caught up in purpose and constricted awareness. This is why I recently converted my Nikon D200 into an infrared camera. I want to keep on learning and exploring. It is the juice that pumps through my veins and keeps me feeling alive.

Poetry is possible in photography when one employs the creative process. The poems live in your vulnerability and in your own tenderness. I think that it is impossible to create images with depth if you're not willing to go to that emotional place—even though that place may be filled with tears. Without the poetry, we are only mechanics. Without the feelings, we are emotionally disabled artists.

I once saw a 'Life Is Good' t-shirt that said 'Sometimes nothing is the right thing to do.' The Zen Masters say that you cannot see your reflection in running water—only in still water. Even a hummingbird comes to rest and is still. It is impossible to be

on this creative journey without incorporating stillness into the plan. It is impossible to be grounded without coming home to yourself. In that stillness, you remember what you already knew and are able to provide a home for the poetry. 'And the end of all our exploring,' said T. S. Eliot, 'will be to arrive where we started and know the place for the first time.' Out of the stillness, a mirror reflects you back to yourself.

We have a gift to show others what may be invisible to them. I enjoy all aspects of photography, but I think that this ability to show others details they may be missing is why I particularly enjoy macro photography. When a viewer sees a small dew drop on a petal, a butterfly close-up, the beauty and grace of leaf, or a small reflection in a river, I feel blessed to be able to share that beauty with the universe. For me, macro photography is a way to express intimacy and to appreciate the small moments that are often overlooked and underappreciated.

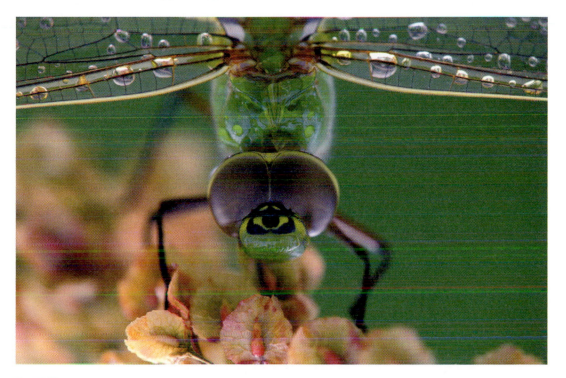

Figure 3.11

Photography can be more than a great image. Photography can be about bringing your light from the deepest center of your being. Photography can be about saying grace for the moment, for each other, for our attention—our affection—our affect.

Ansel Adams said that 'We don't make images with just a camera. We make images with the books we have read, the music we have heard, the people we have loved.' Surround yourself with all that is beautiful and make the ordinary the sacred. The creative moment is when all who you are and what you have experienced 'arrives'—and then you send it out to the universe. In that offering, there is a transformative energy that heals, that creates, that makes the world a better place.'

The Cameras

Which Nikon Camera?

The current line-up of digital SLR cameras from Nikon is better than ever. The new digital cameras from Nikon are packed with features based on input and advice from numerous photographers, including professional and advanced amateurs as well as a whole new group of SLR users now being termed 'pro-sumers.' Any of the new Nikons can be used for family snapshots or professional quality output. Which camera you select depends on the application, output needs, and of course the limits of your pocketbook!

The Nikon D40

This is the camera that blurred the line between the mid-level point and shoot and the entry level SLR. When you present savvy consumers with an option to spend $50 or $100 more and get a true SLR, with its larger sensor and better image quality, it quickly becomes a no-contest situation. The Nikon D40 quickly changed the digital camera landscape, and made the digital SLR an affordable option for a whole new market. It's no wonder with the wealth of features included in the price.

The D40 features a high-performance 6.1-megapixel sensor with easy operation and intuitive controls. This allows even first-time SLR users to easily capture great images. With its bright, 2.5-inch color LCD

Figure 4.2

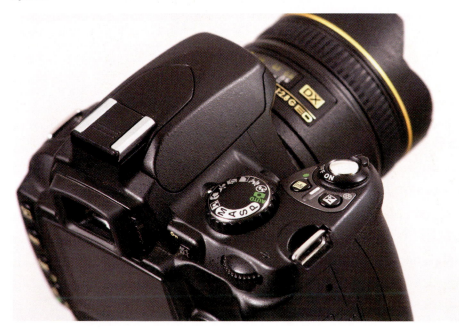

Figure 4.3

monitor and three colorful display options, playback images are easy to see and function menus are easier to use. The large LCD monitor enables image preview up to 19 times magnification and includes large type fonts and easy-to-view menus as well as three all-new display options: classic, graphic and wallpaper.

Nikon's new DX-format CCD image sensor delivers vivid color and sharp detail—great for making beautifully detailed enlargements up to 16 × 20 inches. Compared to a point and shoot camera, the larger, higher resolution CCD sensor allows for much more creative cropping options.

The D40's Optimize Image setting allows the adjustment of color, contrast and sharpening, and several other image settings according to the type of scene or output desired. Settings include: normal, softer, vivid, more vivid, portrait, custom, and black and white, each of which is automatically adjusted

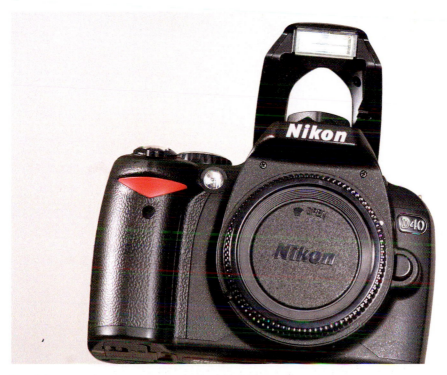

Figure 4.4

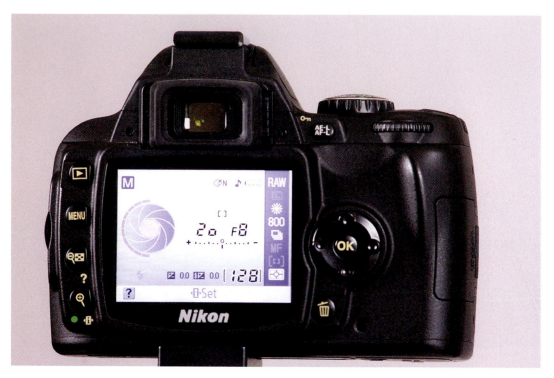

Figure 4.5

based on sophisticated Nikon algorithms or via user-selected settings. Weighing in at just over a pound, the D40 is Nikon's smallest digital SLR ever—eliminating one of the most common complaints regarding SLR cameras.

The Nikon D80

The all-new Nikon D80 boasts an extraordinary 10.2-megapixel DX-format sensor with exclusive EXPEED image processing. This provides even more cropping freedom and the ability to make larger prints. With faster startup, and a split-second shutter response of up to three frames per second, the D80 eliminates the frustration of annoying shutter lag, capturing split-second action for as many as 100 consecutive JPEG images!

Playback images are easy to see and function menus are easier to use with a larger and brighter color LCD monitor. As in the

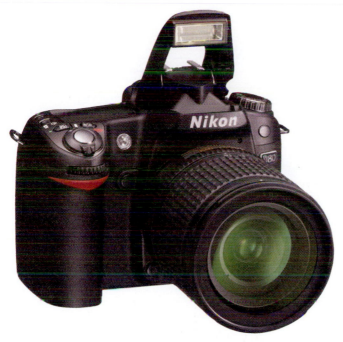

Figure 4.6

Figure 4.7

Figure 4.8

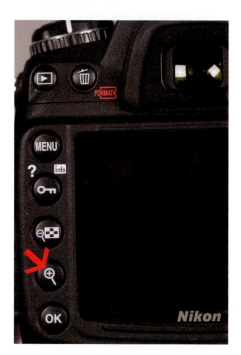

Figure 4.9

D40, the large 2.5-inch LCD monitor enables image preview at up to 19 times magnification and has large-type fonts with easy-to-view menus. Auto rotating LCD display provides automatic horizontal and vertical graphic display orientation, and the supplied EN-EL9 rechargeable battery will allow for shooting up to 500 images per charge.

The D80 features the same image optimize setting as the D40, which affords the user a wealth of output control based on the type of scene and desired results. Nikon's new Active Dust Reduction System activates automatically, to reduce and virtually eliminate annoying dust on the sensor.

The Nikon D300

This professional level DSLR features a 12.3-megapixel DX-format CMOS sensor (1.5×) and Nikon's exclusive EXPEED image

Figure 4.10

Figure 4.11

processing system powering many new features. Images are internally processed in full 16-bit color, creating exceptionally rich tones and natural color gradation. The high-resolution 3-inch LCD screen with the built-in magnification function enables close monitoring of the focus and lighting of your exposures.

A benchmark feature of the newest Nikon cameras is the ability to create image overlays and multiple exposures of 2–10 frames in-camera. The ability to take advantage of and hone these creative techniques in the field is extremely valuable.

The D300 is equipped to handle shadows and highlights better than ever with Active D-Lighting, a new image optimization setting to achieve a greater dynamic range through exposure compensation and selective tonal adjustment. This feature simultaneously compensates for bright highlights and retains detail in the shadows, which is great for shooting in bright sun or for brides walking down the aisle.

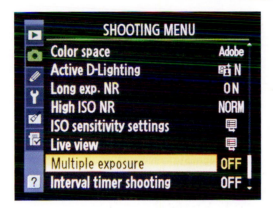

Figures 4.12 It is a simple matter to set up the multiple exposure feature in the D300's Shooting Menu.

A new feature for Nikon cameras is an advanced 51-point dynamic auto focus mode, which can track even randomly moving subjects to provide sharp focus. Alternatively, you can use a group of 21 points, 9 points, or select one focus point, depending on the movement of the subject.

A broad range of light sensitivity settings from ISO 200 to ISO 3200 is available, extended with ISO 100 equivalent Lo-1 and ISO 6400 equivalent Hi-1. A key feature of the newest Nikon cameras is impressive High ISO noise reduction, allowing for professional-quality shots even up to ISO 6400. This allows you to really take advantage of low lighting situations without sacrificing image quality.

Another feature of the D300 is the real-time live view capability, where images can be composed on the 3-inch LCD screen as it displays what is seen through the lens. This is great for shooting from challenging angles, or aligning scenics and landscapes with the horizon.

With the D300's improved capability of shooting six frames per second (or 8 fps with a battery pack), the finest nuances of the moment can be captured with split-second timing. The battery life has also been extended to last approximately 1000 frames in normal JPG mode, versus the D200 which only lasts for around 350 frames using the same lithium battery.

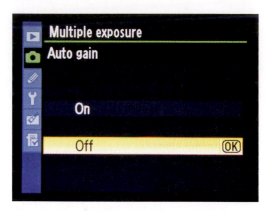

Figures 4.13 It is a simple matter to set up the multiple exposure feature in the D300's Shooting Menu.

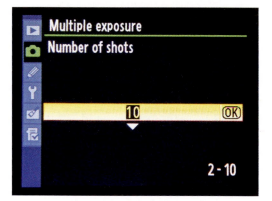

Figures 4.14 It is a simple matter to set up the multiple exposure feature in the D300's Shooting Menu.

The D300 is also equipped with Nikon's superb built-in Speedlites and i-TTL flash control. The shutter mechanism is rated for 150,000 actuations.

The Nikon D3

The incredible D3 is Nikon's top of the line pro camera, and is the first in the line-up to use a 25 × 36 mm full-frame sensor—a surface area equivalent to 35 mm film. A full-frame sensor

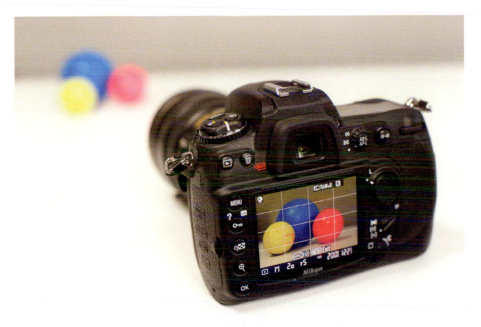

Figure 4.15 The live view feature allows for quick and easy composition, both in and out of the studio.

Figure 4.16

Figure 4.17 Continuous shooting mode combined with auto focus tracking provides the ability to really capture the moment with split-second accuracy.

delivers the benefits of a larger file size, greater lens choice, and being able to utilize the range for which lenses were designed.

Many of the groundbreaking features in the D3, such as the 51-point dynamic auto focus, live view, Active D-Lighting, and in-camera multiple exposures, overlays, and filters, are carried over from the D300 but delivered at a faster speed.

In continuous mode, the D3 can record 9 fps with auto focus tracking (11 fps without). The D3 is clocked as having the fastest power-up, shutter lag, and blackout times of any DSLR, making it perfectly suited for photojournalism and sports photography but also excellent for any photographic field.

Now you can shoot a perfectly level skyline every time with virtual horizon, found only in the D3. This feature utilizes a

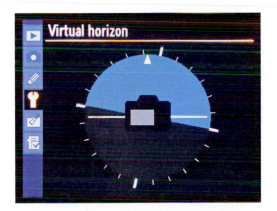

Figure 4.18

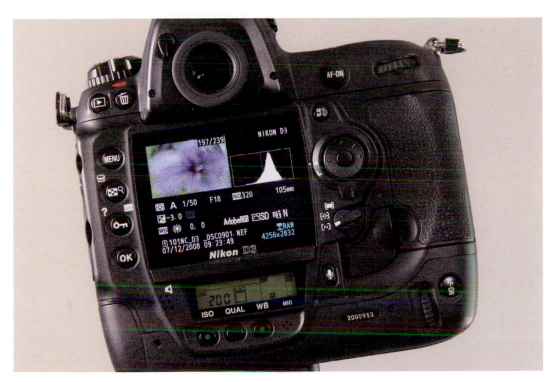

Figure 4.19

cockpit-style screen displayed on the 3-inch LCD monitor to make sure you get the perfect angle without time-consuming processing after the event.

Like the D300, the D3 handles noise at high ISOs but is even more remarkable, creating incredibly sharp images at ISO 6400 where even the D300 begins to soften. There is also an extension to ISO 25600 available.

The camera itself is sealed against dust and moisture, and made of magnesium alloy. Two compact flash slots allow for overflow after filling up one card—recording RAW files on one and JPEG on the other—or to back up data on the second card. The impressive battery life is good for approximately 3000 shots in normal JPEG format. The D3 is rated for 300,000 shutter cycles.

Shooting Modes

Which Shooting Mode Do I Choose?

In a nutshell, your selection of shooting mode will determine the level of control you exercise over the camera during the image capture process. Leaning toward the automatic modes certainly means you will most likely get a technically correct exposure, but it also means you are sacrificing artistic control. Shooting in full manual mode provides total artistic control but demands the utmost attention to detail and some basic knowledge of exposure. You can decide which way to go based on how much control you want to have, and your familiarity with the relationship of shutter speed, aperture, and ISO. The beauty of the Nikon design is the ability to move gradually from the fully automatic modes to the more advanced creative modes. You can decide at what point in the process you are most comfortable and work from there.

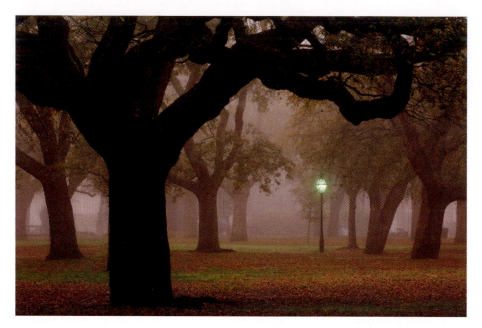

Figure 5.2

Figure 5.3

Full Auto

In Full Auto mode, characterized by the little green camera and the word 'Auto,' the camera decides shutter speed, aperture, white balance, and ISO. All this is based on what you see through the viewfinder and Nikon's pre-programmed algorithms in the camera CPU. You, the user, have only to press a button and the camera does the rest. Sounds like a dream come true, and in a perfect world that would be the case, but as with all things in life there is a trade-off. It is true that the fully automatic mode will almost always yield a 'technically correct photograph,' in that the combination of shutter speed, aperture and ISO settings will produce a usable image, but your ability to use shutter speed, aperture, and ISO creatively is no longer an option. Notice in Full Auto mode that many of the menu items are grayed out and no longer available to the user. Basically there is a valid assumption by the manufacturer that those who select this mode should not be fooling around with settings such as white balance, ISO, RAW files and the like.

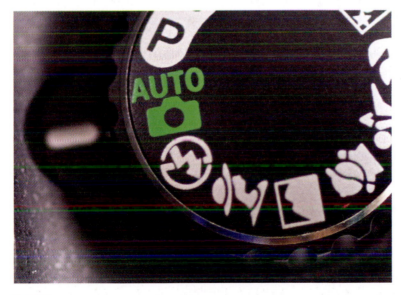

Figure 5.4

Creative Photography: Digital Vari-Program Modes

In addition to the Full Auto mode, many Nikon Digital SLR cameras provide the *Digital Vari-Program* modes. Choosing one of these modes automatically optimizes the settings to suit the selected scene. This provides beginners with a more creative style of photography with the ease of rotating a dial. Your choice of which one to use should be based on the combination of shutter speed and aperture that each mode produces by default.

Auto Flash Off

This will turn off the built-in flash. Use this when you find yourself in an area where flash photography is prohibited, such as in some museums. You can also use this when you want to capture subjects under low light with a more natural look. The camera will select the focus area with the closest subject and the AF assist illuminator will light to aid in focus situations where the light is poor. With the addition of a tripod this mode works well for photographing interiors without the harsh light and hot spots resulting from using a flash.

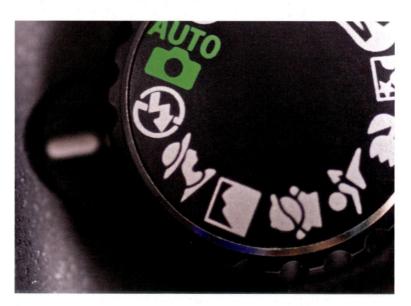

Figure 5.5

Portrait Mode

In the Portrait mode, the camera will use larger apertures in order to place more emphasis on the subject and lend the composition a sense of depth. Use this for portraits with softer, natural-looking skin tones. The camera will select the focus area with the closest subject. Portrait mode is also handy for any situation where a wider aperture and faster shutter speed are desired to produce an out of focus background and minimize camera shake. The camera also defaults to continuous drive shooting mode to allow several shots of the subject in rapid succession.

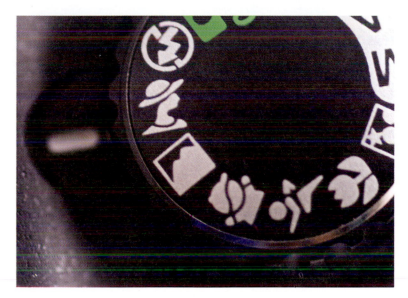

Figure 5.6

Landscape

Use this setting for scenes requiring a larger depth of field, such as a mountain or beach scenic, or any situation with a subject in the distant horizon. The camera will automatically choose a smaller aperture setting depending on available light. Most of the time the aperture will fall somewhere in the middle of the range to provide good depth of field but still allow for a fast enough shutter speed to eliminate camera shake.

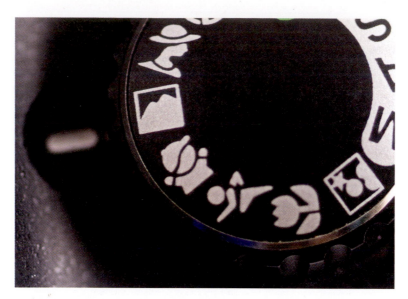

Figure 5.7

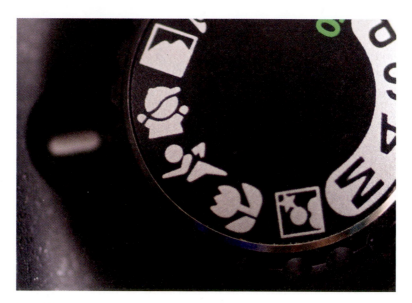

Figure 5.8

With the addition of a tripod, Landscape mode is a good choice for shooting interiors. The built-in flash and AF assist illuminator turn off automatically.

Child

This is a great quick set-up for snapshots of children. Clothing and background details are rendered crisp and sharp, while skin tones are softened to give a more natural look. The camera automatically selects the focus area containing the closest subject.

Sports

Higher shutter speeds freeze motion for more dynamic sports actions shots. The camera will automatically choose faster shutter speeds with a larger aperture, but depending on available light will allow enough aperture to create more depth of field than Portrait or Close-up modes. As light levels begin to fall off, the camera will automatically open the aperture to maintain a faster shutter speed and the shutter

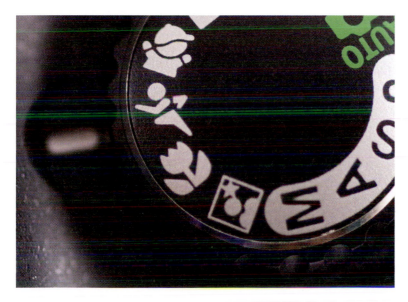

Figure 5.9

speed will only start to slow down when maximum aperture is reached. A combination of freezing the subject and blurring the background places emphasis on the intended subject. The camera automatically focuses continuously while the shutter release is pressed halfway, tracking the subject in the center focusing area. If the subject leaves the center focus area, the camera will continue focusing based on information from the other focus areas.

Close-up

Use for close-up or *macro* shots of flowers, insects, coins, or any small objects. The camera will automatically focus on the subject in the center focus area. Other focus areas can also be designated using the multi-selector. Aperture is adjusted so as to focus attention on the subject but the maximum aperture of the lens is avoided because the closer you are to your subject, the smaller the depth of field. In this manner the camera allows enough collective focus to highlight more than just a small area of the subject. The addition of a tripod is recommended to avoid blurring. If you really enjoy macro photography we recommend

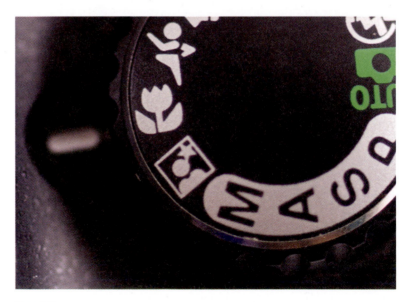

Figure 5.10

the addition of a macro lens to your arsenal. Macro photography will add a whole new dimension to your work.

Night Portrait

This mode allows for a natural balance between the subject and the background in low light portrait situations. The camera will automatically focus on the subject in the center focus area. The addition of a tripod is recommended to avoid blurring, as the camera will automatically keep the shutter open long enough to capture the subject with the flash, and continue to stay open long enough to effectively render the background as well. Night Portrait mode works great indoors too, as well as in any situation where background detail is desired.

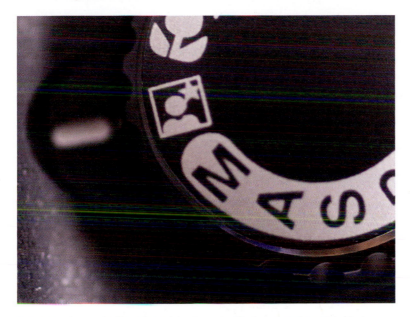

Figure 5.11 An example of how advanced shooting modes allow for more creative control of the image.

Advanced Shooting Modes

P, S, A, and **M** modes offer a great deal more control by allowing access to a variety of advanced settings including white balance, ISO and Image Optimization to name a few. Each setting allows for differing degrees of control over aperture and shutter

speed. These are the modes of choice for professional and most advanced photographers.

Figure 5.12

Program Mode (P)

In Program mode, represented by the 'P' on the mode dial, the camera decides on aperture, and shutter speed, but the user is allowed to select or set a custom white balance. In Program mode you can also select ISO, and several other user defined variables. The Program mode has a flexibility feature built in: rotate the command dial to the right and larger apertures and faster shutter speeds are chosen, resulting in smaller depth of field (blurred background) as well as the enhanced ability to freeze action. Rotate to the left and smaller apertures and slower shutter speeds are chosen for a larger depth of field (more of the total subject area is in focus) and more shutter lag, allowing enhancing the

depiction of motion. This is an excellent way to learn more about aperture and shutter speed yet still have the safety net of the camera's Program mode intact. In Program mode you can also make use of the camera's exposure compensation feature for difficult situations such as a dark subject with a light background. Program mode is thus a good starting point for anyone new to the world of the SLR but also wanting some creative control during the acclimation process.

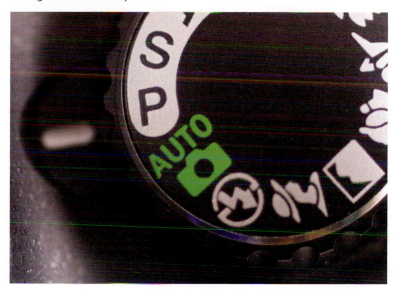

Figure 5.13

Shutter Priority (S)

In Shutter Priority mode, the user selects the shutter speed and the camera automatically sets the aperture based on ISO and existing light. This is useful for many sports shooters who wish to use the fastest shutter speeds to freeze action, use a slower shutter speed to imply motion, or anything in between. This is a valuable tool for photographing moving objects of any type as you can vary the shutter depending on the speed of the subject and the degree of blur you want. If you see the blinking flash symbol and 'lo' in the viewfinder it is the camera's way of telling you that there isn't enough light for the chosen shutter speed and aperture combination.

Figure 5.14

Figure 5.15

Aperture Priority (A)

In Aperture Priority mode the user selects the aperture based on the desired depth of field, and the camera automatically selects the shutter speed based on ISO and available light. If getting a certain depth of field is more important to you than setting the shutter speed, Aperture Priority mode should be your choice. This is helpful for photographers who tend to think and compose based on depth of field. Landscape photographers tend to prefer a smaller aperture for maximum depth of field. Wedding and portrait photographers more often want an aperture setting anywhere from wide open to around f/8 for minimum to medium depth of field depending on subject. We like Aperture Priority mode for just walking around with the camera and grabbing snapshots. This eliminates the time involved in setting shutter speed and aperture in manual mode and losing the moment. When photographing people, in particular, I just set the aperture to f/5.6 or f/8 and stay in Aperture Priority mode. As soon as someone becomes aware of the camera the candid shots are lost.

Figure 5.16

Manual Mode (M)

Manual mode affords the highest level of control but is also the least forgiving of user error. In manual mode the user sets the shutter speed and aperture based on artistic intent. The in-camera meter is used to adjust shutter speed and aperture based on ISO and existing light.

We tend to do most of our shooting in manual mode simply for the level of control it affords. There is no need for exposure compensation or making additional allowances as the camera can be set exactly where we know it needs to be to get the desired effect. Of course it takes a lot of practice to master the level of control this affords, but the time and effort are well worth it.

A good hand-held light meter is a recommended accessory as well. You can better measure all aspects of the set-up and take a lot of the guesswork out of the equation.

Figure 5.17

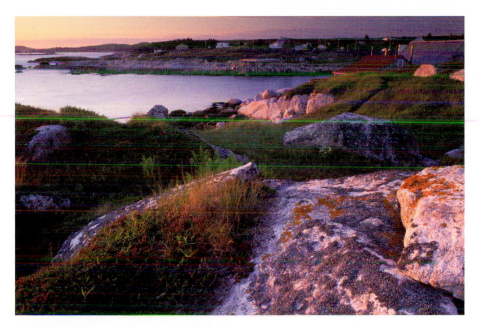

Figure 5.18

Figure 5.19

Sue Milestone

Susan Milestone is a professional nature and fine art photographer and workshop instructor, conducting workshops throughout the continental United States and Canada. Her work has been published in *Nature's Best* magazine and included in the 100 Best of the Best Images. She is a fine art digital print maker and her prints are exhibited and sold throughout the country.

She is known for her creative use of image overlays and multiple exposures which can be performed in-camera using Nikon's professional DSLRs (D300, D3, D700). One of her favorite techniques is to combine a straight shot with a multiple exposure of the same image using the image overlay function in the Nikon camera.

'I got my start in photography because of my love of nature and hiking. I wanted to be able to translate the beauty I saw in nature to the photographic process. My first camera was a Nikon FM2. I think being forced to learn photography with a manual camera was a tremendous help in better understanding the entire exposure process. I have always used Nikon equipment. I currently use the Nikon D300.

The great thing about digital is being able to see your results right away in the field, especially with multiple exposures. If you don't get what you want the first time you can keep trying until you do. You don't have to wait until you get home to see the results. It is also much faster to do it in the camera rather than taking separate files and putting them together in the computer.

Flowers are some of my favorite subjects to photograph and with the image overlay and multiple exposure features in the Nikon cameras, the possibilities are endless. For flower photography my main lens is the Nikon 300 mm f4 which I use alone and with extension tubes and tele-converters. I love the soft backgrounds that the long lens gives me. When you photograph in public gardens you can't always get as close to your subject as you would like, so by using the 300 with a tele-converter I can fill the frame with the flower even when I'm a good distance away.

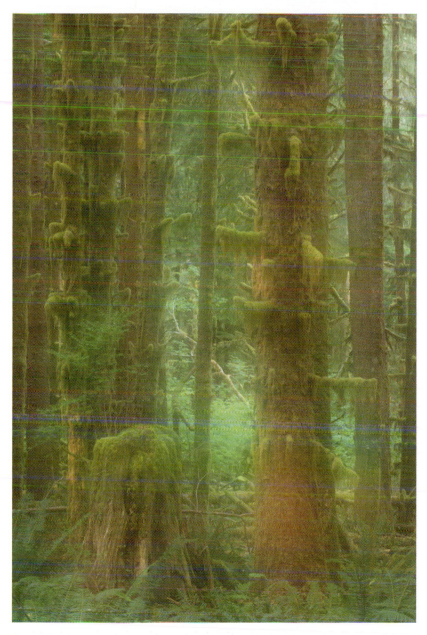

Figure 5.20

Teaching photography workshops gives me the opportunity to travel to many amazing places. To me, it is as important for me to be immersed in nature for nature's sake, not just to photograph it. Some of my favorite places are Acadia National Park in Maine, the Hoh Rainforest in Washington State, Nova Scotia, and the Smoky Mountains.'

Getting Good Color and a Good Exposure

Color Temperature and White Balance

The ability to set or adjust your own white balance on your camera is one of the greatest tools available to the digital photographer. Film shooters well remember using various filters to try to balance the color temperature of the light with the rated color temperature of the film. We remember the familiar blue cast created with the combination of daylight rated film and early morning or late evening fog. Below are the different available white balance settings on your camera and their approximate color temperatures:

- Incandescent 3200k
- Fluorescent 40,000k
- Direct Sunlight 5200k
- Flash 5500k
- Cloudy 6000k
- Shade 7000k

When you set the white balance on your camera you are in effect adjusting the color temperature of the image capture to try to best match the actual color temperature of the existing light. If the color

temperature is actually higher than your white balance setting you will get a blue cast to the image; if the color temperature is actually lower than the setting on your camera you get a red cast. The upside to this equation is that we can use white balance as a creative tool just as we can shutter speed and aperture. At times, a certain colorcast can add dramatic effect to an image. In Figures 6.2 through 6.5, notice the same scene captured with four different white balance settings.

Photography is rife with inverse relationships, so confusingly, but not surprisingly, higher kelvin values are representative of cooler light, while lower kelvin values indicate warmer light. If you wish to add a warmer look to your images, just set the white balance color temperature higher than the actual color temperature; if you want to add a cooler look to your subject, set the white balance color temperature lower than the actual ambient light

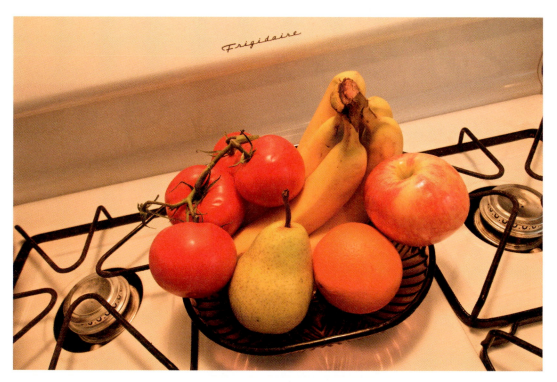

Figure 6.2 Fluorescent White Balance

Figure 6.3 Daylight Preset

Figure 6.4 Custom White Balance

Figure 6.5 Auto White Balance

temperature. The camera will automatically add either a red or blue cast accordingly. Often even a slight adjustment in color temperature can make or break an image, so learning how to manipulate color is a valuable tool worth studying and learning.

Also keep in mind the flexibility of changing the color temperature after the event that the RAW (NEF) format affords. This gives us the additional option of using color temperature in place of the warming and cooling filters we used to use with traditional film photography.

Custom White Balance

If you are after the most accurate color, with no manipulation, then setting a custom white balance is the best way. By setting a proper custom white balance, the camera will 'know' the exact

Figure 6.6

Figure 6.7

Figure 6.8

color temperature of the existing light and add just the right amount of red or blue to get accurate results.

To set a custom white balance, you will need a neutral gray or white target. Many companies make specialty targets and devices, and devices just for this purpose, but in a pinch even a plain white piece of paper will do. Here we will demonstrate the process using a D3.

1. Press the white balance button (WB) on the rear of the camera and rotate the command dial until 'Pre' is displayed in the rear control panel.
2. Release the WB button and then press again until you see the flashing 'Pre'.
3. Hold the target so the dominant source of light is falling on it, fill the frame, and shoot the target. A proper exposure is

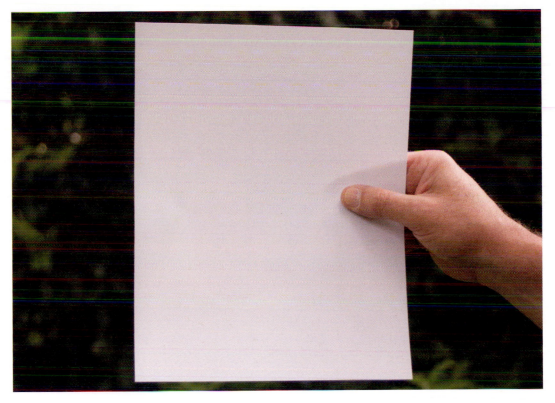

Figure 6.9

necessary so use AV mode. You can turn auto focus off, as it is not necessary to have the target in focus.

4. Shoot the target and look for the flashing 'Good.' If the camera was unable to obtain an adequate measurement the display will flash 'nGd.'

5. Make sure the preset d-0 shows on the LCD.

The camera will now use this information as a white balance color reference until you change the white balance setting. Remember, you will need a new custom white balance whenever the light changes.

Focusing and Exposure

No matter how creative your ideas, or how artistic your composition, proper focus and exposure are still necessary to

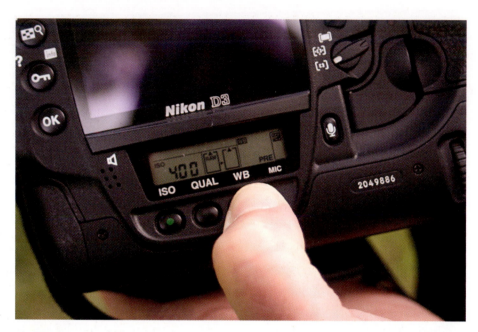

Figure 6.10

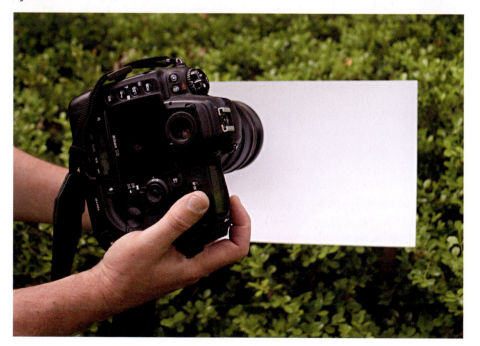

Figure 6.11

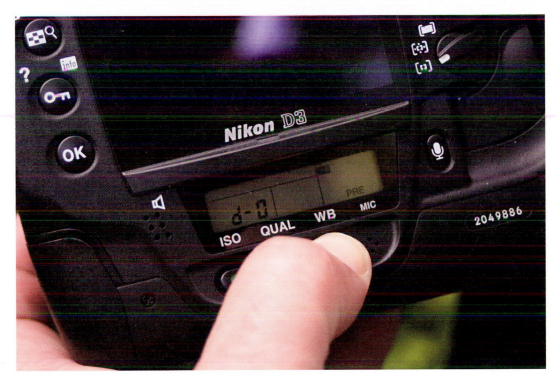

Figure 6.12

your success. Whether you use auto focus or focus manually, and whatever metering mode you use, focusing critically and setting a proper exposure will make the difference in getting the shot.

Metering Modes

Nikon cameras all have three metering modes: Matrix, Center-Weighted, and Spot. Learning to pre-visualize the end result of each type of metering in different shooting situations will be a huge boon to your ability as a digital photographer. Another factor to consider is that you paid a lot of money for this technology, and with it the ability to go beyond the basic 'auto-everything' function of a point and shoot camera, so by all means learn to use it and get your creativity and money's worth.

3D Color Matrix metering is one of Nikon's flagship developments in the photographic industry. Using thousands of

pre-programmed in-camera algorithms covering virtually every possible shooting situation, a Nikon camera in Matrix metering mode literally does the thinking for you. We recommend Matrix metering for most situations. The camera will meter a wide area of the frame and set the exposure according to the distribution of brightness, color, distance, and composition.

With **Center-Weighted** metering, the camera meters the entire frame but assigns greatest weight to the area in the center of the frame. The camera defaults to an 8-millimeter circle in the center of the viewfinder but if a modern CPU lens is attached, the area can be selected using the Custom Settings Menu. Even with non-CPU lenses you can improve the performance of this mode by specifying the lens focal length and maximum aperture in your camera's non-CPU lens data menu. Center-Weighted metering works well for portraits or any situation where the subject is concentrated in a central area of the frame.

Figure 6.13

Figure 6.14

Figure 6.15

With **Spot** metering, the camera meters approximately 2% of the frame viewing area. This small circle is centered on the currently selected focus point, which makes it easy to meter off-center subjects. If you are using a non-CPU lens the camera will automatically select the center focus point. Spot metering is best for situations where the background is much brighter or much darker than the main subject.

Focusing

We are sticklers for sharp images and so for us critical focus is a necessity. If an image is even slightly soft it isn't considered usable. Focusing well and critically should be as much a part of your regimen as turning on the camera. You also need to be aware of where you focus (point of focus) as well as how you focus. You should keep in mind your aperture, depth of field, and your artistic intent when choosing your focus point. Nikon

Figure 6.16

Figure 6.17

Figure 6.18

cameras and lenses offer some of the most advanced focusing mechanisms available.

Single Servo AF (S)

In Single Servo AF mode, the camera focuses when the shutter release is pressed halfway. The focus remains locked as long as the shutter release is held down halfway. Pressing all the way down will release the shutter. This allows for locking focus, and recomposing prior to releasing the shutter. In the default camera settings the shutter can only be released when the subject is in focus, indicated by the in-focus indicator showing in the viewfinder. For most general purposes, this is the mode of choice. You will be able to control the point of focus and the moment of shutter release in one easy step. Many photographers, myself included, use this mode to set focus on a particular point, turn the AF 'off' on the lens, and then recompose the image. This gives the added benefit of selective focus and the superior accuracy of the camera's auto focusing capability over your ability to manually focus.

Continuous Servo AF (C)

In Continuous Servo AF, the camera will focus continuously while the shutter release is pressed halfway down. Focus will track with the subject and if the subject moves, Nikon's Predictive Focus Tracking will adjust the focus as necessary based on the speed and distance from the subject. This is obviously the focus mode of choice for sports and action photography. My brother-in-law finds this his focus mode of choice as his son is big into soccer, his dog is a Frisbee nut, and he is into capturing every precious moment!

Manual Mode (M)

In Manual Mode the camera has no automatic focusing capability and all focusing is done using the lens focus ring. Using any aperture setting faster than f/5.6 will enable the in-focus indicator in the viewfinder. In this mode photographs can be taken at any time, regardless of focus. You can use the camera's electronic rangefinder to set focus by pressing the shutter release halfway and rotating the focusing ring until the in-focus indicator is displayed in the viewfinder. Manual mode

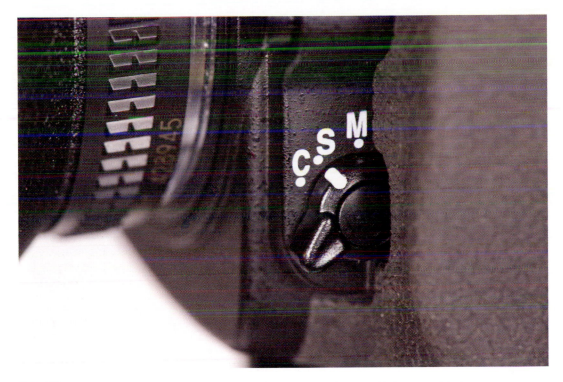

Figure 6.19

is quite useful in landscape and macro photography, or any situation where you want to choose a particular focus point without having to focus and then recompose the image. There will also be times and situations where your camera's auto focus system simply will not work, due to low light and/or a lack of contrast, and manual focus may save the day.

Focus Point Selection

In addition to the various focusing modes Nikon also allows a wide variety of focusing points to select from, depending on your camera model. With the D300 and the D3, for example, there are 51 focus points—covering a wide area of the viewfinder—to select from, while the D80 offers 11. Using a combination of the camera's AF Area Mode selector and the Focus Selector, you can select both the number of focus points

and the focus area of your choosing. Pressing the info button at any time on the rear of the camera will show you the currently selected focusing area.

Jack Kennealy

Jack Kennealy is a Maine-based photographer specializing in nature and fine art photography. In addition to producing beautiful fine art images, Jack is just a great all-around guy. Jack's images and his prints have a marvelous aesthetic character, matching the timeless nature of Maine's incredible beauty.

In addition to exhibiting in Northeast shows and galleries, his work is regularly published in newspaper, magazine, and web media. Jack's images have won awards at prestigious shows in Ogunquit and Falmouth. His fine art *giclée* prints have been acquired by individuals and for collections, not only all throughout the U.S., but also in Canada, Mexico, Europe, Asia, and Africa.

Jack's web site at www.kennealy.com has been cited as Maine's most visited web photography site.

'Growing up in Massachusetts, I was introduced to photography at the age of eight by 'helping' in Dad's darkroom, but he introduced me to many other things as well. After earning a Ph.D. in physics, my scientific work gave me some extraordinary opportunities for pioneering research in digital imaging of many kinds: graphic arts, satellite, industrial machine vision, astronomical, and even biological imaging, for which I was awarded a far-ranging U.S. patent.

While Vice President of a Maryland biotech company, my life-long photography passion led me to form Chesapeake Light Photography—active in portraiture and landscape photography. My landscape, nature, and architectural images were widely exhibited and earned numerous awards in the Washington, DC area.

In Maine for 10 years—through Kennealy Photography—I've followed my own and my father's passion for photography. My Maine work emphasizes the natural hues of dawn and sunset, with a large focus on the forms and shapes of coastal Maine. Living on the Maine coast inspires and enriches us in countless

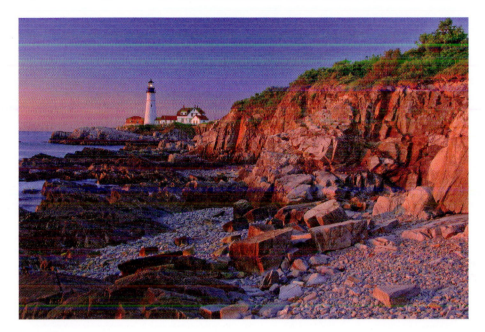

Figure 6.20

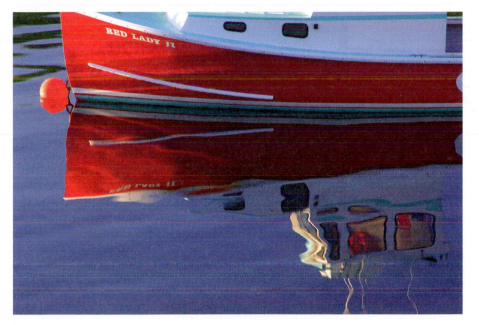

Figure 6.21

ways. All of the ocean's sounds and smells complement its visual bounty. From our hillside home, our vision is gratefully engaged by the sea—and by the sweep of two Cape Elizabeth lighthouses—as well as *all* of Maine's truly special beauty.

Although it is both slower and more expensive than conventional printing, I believe the *giclée* process perfectly complements my photography. It helps me to artistically communicate the special sense of light and place distinguishing so much of my work. I individually print each *giclée* on archival watercolor and other fine art papers, using only pigment based archival inks.'

Nikon Glass

The Nikon Name

The Nikon name has always been associated with top of the line quality, and Nikkor lenses are known throughout the world as among the best. Precision engineering combined with a constant dedication to design excellence has made the Nikon system and Nikkor lenses the choice of many of the world's top photographers.

With the abundance of Nikkor lenses there is a wide variety to choose from, so let's begin by discussing what factors you should consider when choosing the right glass for you. Remember, good lenses are worth the investment, as you will most likely upgrade your camera body before your lenses.

Lens Terminology

Focal Length

Most lenses can be categorized as wide angle, normal, or telephoto *focal lengths*. A wide-angle lens has a shorter focal length, usually 35 mm and under, and is great for capturing scenery or making the most of

Figure 7.2

small spaces. The down side is because so much of the subject angle is compressed into a small area it can also cause barrel distortion.

Normal, or mid-range, lenses with a focal length of 40 mm to 60 mm create images that look most natural to our eyes. With the 35 mm camera format, a 50 mm lens or the equivalent will effectively mimic the field of view of the human eye.

A telephoto lens, generally 70 mm and up, is great for magnifying and isolating distant objects, and properly used can have the effect of blurring backgrounds. On the shorter side (85 mm), many portrait photographers use telephoto lenses; while on the longer side (400 mm), they are the lens of choice for wildlife and sports photographers.

Figure 7.3

Maximum Aperture and Speed

A *fast* lens refers to lenses having a maximum aperture of f/2.8 or more. Faster lenses (lower f/stop value) are expensive, but in return you get top quality—a lens that is bright, sharp, and performs well in low light. Usually, in order to get a lens faster than f/2.8 you will need to purchase a prime lens. The 50 mm f/1.4 and the 85 mm f/1.8 are faster than any of Nikon's high-quality zoom lens. Fast lenses are also good for blurring out your background and placing emphasis on specific areas of an image.

Prime Lenses

A prime lens refers to lenses that have one set focal length and cannot be adjusted. Generally, a prime lens tends to be somewhat sharper than a zoom. Having only one focal length,

Figure 7.4

and the need for fewer elements, reduces distortion and flare. This used to be the reason many pros would forego zooms and use only primes.

Zoom Lenses

Zoom lenses will cover a range of focal lengths. Some zoom lenses can range all the way from super-wide to longer telephoto, and many people new to photography wonder why so many professional photographers have so many lenses when they could have purchased one to cover the entire focal range. The answer lies in the fact that there is a trade-off. In our experience, zoom lenses that exceed $3\times$ range from smallest to largest focal length tend to compromise in overall sharpness and contrast.

With today's technology and manufacturing capabilities, Nikon is producing many zoom lenses that truly rival even the best primes in sharpness, contrast, and color rendition. The use of zooms versus primes is no longer the issue it once was.

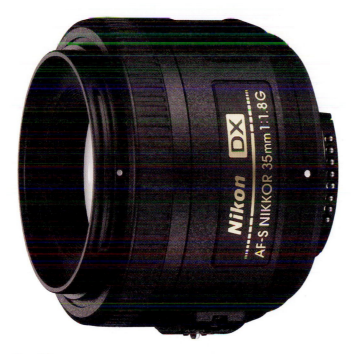

Figure 7.5

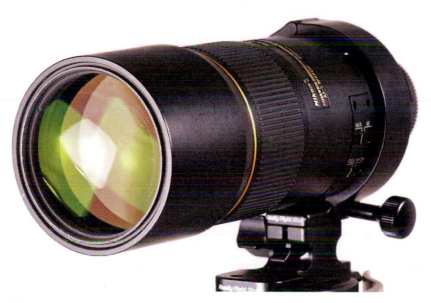

Figure 7.6

Nikon Lens Terminology

Before we talk about specific choices, let's go over some feature codes of Nikon's *Nikkor* lenses:

- **VR:** Designates Nikon's Vibration Reduction technology which, using a built-in sensor system, shifts lens elements to counteract camera shake or movement, thus allowing shooting at much slower shutter speeds than with traditional lenses.
- **ED:** The ED designation indicates the lens has elements made of extra-low dispersion glass, resulting in the reduction of chromatic aberration, flare, and other optical defects. Some lenses use an LD (low dispersion) or UD (ultra low dispersion) marking.
- **IF:** IF designates an internal focusing mechanism. The lens length does not change as the lens is focused.
- **D:** A lens with a 'D' designation has the added capability of measuring distance from the camera to the subject and adding this to the metering information used by the camera to determine exposure. This is extremely valuable in flash photography.
- **AF, AF-D, AF-I, AF-S**: Designates a lens as having auto focus. The second letter provides additional information: D is a D-type lens; an I lens focuses through an internal motor; an S lens focuses or fine-tunes focus manually even with AF engaged.
- **DX:** All DX lenses are designed exclusively for use with digital cameras having the 1.5× crop factor. Their coverage circle isn't officially large enough to fill up a full 35 mm frame. The digital only design means that these lenses can be smaller and lighter than their full-frame counterparts.
- **Micro:** The term micro is Nikon's designation for a macro lens.

Some Nikkor Lenses to Consider

18–200 mm f/3.5–5.6G ED-IF AF-S DX VR II

18–135 mm f/3.5–5.6G ED-IF AF-S DX

If you are starting out and want one lens that 'does it all,' then the 18–200 mm or the 18–135 mm is the lens for you. Many professionals have one of these as their travel lens. Often, one of these lenses will come with the D80 or D300 if you purchase a kit, which is great value for the entry level DSLR

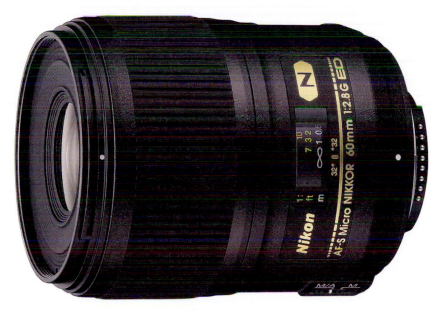

Figure 7.7

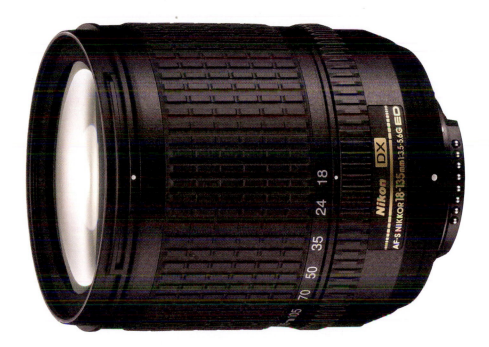

Figure 7.8

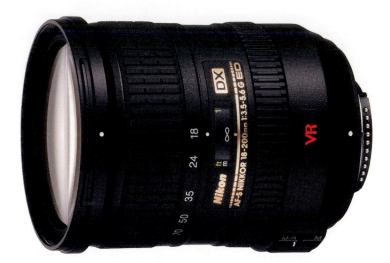

Figure 7.9

shopper. These large zoom ratios cover wide angle to telephoto, and offer one-stop shopping for a lens that can be used in almost all situations. There is no need to change lenses, which helps avoid dust on the sensor. The difference between the two lenses, besides added focal length and price, is that the 18–200 mm offers Nikon's Vibration Reduction, allowing an additional stop to two stops of hand-held shooting versus the 18–135 mm. However, the slow variable f/stops (3.5–5.6) on both means they can be unreliable in low light conditions.

12–24 mm f/4G ED-IF AF-S DX

24–120 mm f/3.5-5.6G ED-IF AF-S VR

For users of DX cameras (D300 et al.), an excellent two-lens travel kit is the 12–24 mm and the 24–120 mm. This gives the photographer a continuous super-wide angle to telephoto range. The one trade-off is less telephoto range, but there is more wide-angle range and the lenses are faster than the 18–135 mm.

Either of these set-ups would well serve the amateur travel photographer or anyone wishing to avoid traveling with several lenses.

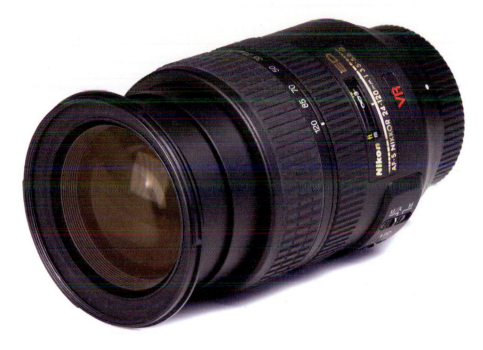

Figure 7.10

17–55 mm f/2.8G ED-IF AF-S DX

The 17–55 mm f/2.8 is a quality lens for photojournalism and street photography. The wide angle (17 mm) to 55 mm (normal lens) is perfect for working in tight situations and general walk-around photography. This is a fast high-quality lens delivering professional results.

14–24 mm f/2.8G ED AF

This is one of our three 'workhorse lenses.' It is great for landscapes, and for use in tight quarters. When pointing the camera straight and not angling upwards or downwards, the edge lines are straight with no bowing distortion as in a 15 mm fish-eye lens. Of course, when angling the lens up or down you will get a *keystone* effect, where the image dimensions will be

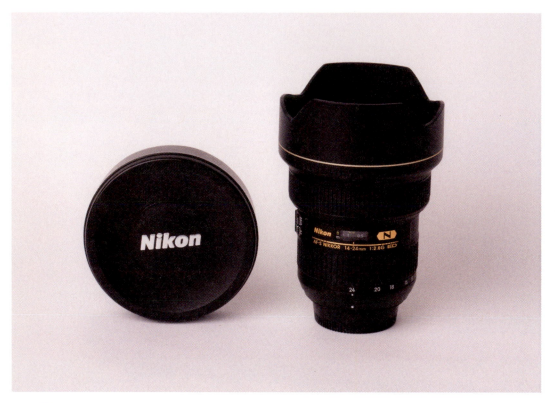

Figure 7.11

distorted like a trapezoid. This effect can be distracting or can add to the drama of your composition as a creative technique.

24–70 mm f/2.8G ED

This lens is the one that I grab first when arriving at a scene. This wide angle to short telephoto range is the most common range used in many situations. A little known fact about this lens is that the close focusing distance is less than 12 inches, which is excellent for creating dramatic wide-angle images.

Telephoto 70–200 mm f/2.8D G-AFS ED-IF VR

This is a very versatile lens. It has a little weight to it, but the Vibration Reduction enables one to hand hold the camera at

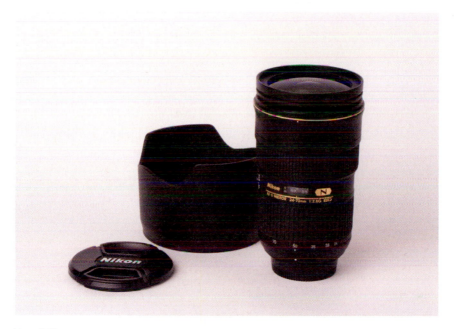

Figure 7.12

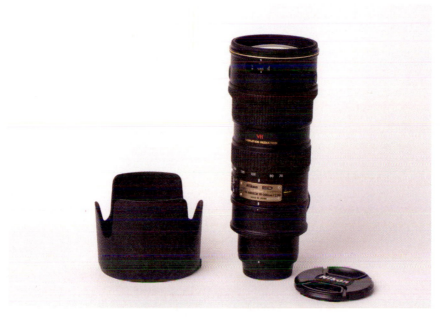

Figure 7.13

lower shutter speeds than the hand-holding rule of 1/the longest focal length of the lens, 1/200. The ED glass and warm coating renders skin tones well, which is a great asset in sports, wedding, and portrait photography. This lens is also an excellent scenic lens, able to pick out smaller areas of a large scene.

Telephoto 300 mm f/4D ED-IF

This is a manageable long telephoto, fitting easily into a camera bag and about the same weight as the 70–200 mm VR lens. It's bright and razor sharp, as long as you're on a solid tripod and use a cable release. With a minimum focusing distance of an incredible 4 feet, this is an outstanding lens for flower photography. Adding extension tubes enables closer focusing and the bright f/4 aperture keeps the viewfinder bright even

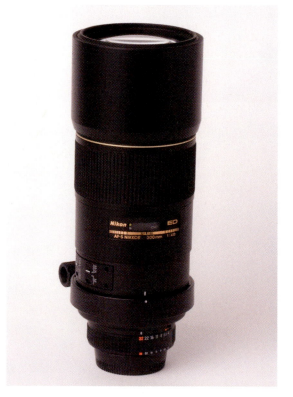

Figure 7.14

when using extension tubes and tele-converters. This is also an excellent wildlife lens.

Telephoto 300 mm f/2.8, 400 mm f/2.8, 500 mm f/4, 600 mm f/4, 800 mm f/5.6

If you're serious about sports or wildlife photography, these are the babies you'll be considering.

When you notice the long lenses at sporting events, or see professional bird/wildlife photographers' long lenses, you're probably looking at some of these. They are very expensive and very heavy. Many of the lenses you see at sporting events are owned by the news organizations or the like and are on loan to the photographers. The great majority of the images you see published in *Sports Illustrated* are shot with these lenses, as are

Figure 7.15

images of the Olympics. These lenses are almost always shot wide open to achieve a sharp subject and very soft background. This effect can be achieved with shorter lenses, like the 300 mm f/4, but not at as great a distance from the subject.

60 mm f/2.8G ED Macro, 105 mm f/2.8G ED-IF AF-S VR Macro, and 200 mm f/4D ED-IF Macro

All Nikon macro lenses are outstanding. One of the main factors in choosing a macro lens is the working distance. For example, if you need to be 6 inches from your subject using a 60 mm lens, you'll be 12 inches from the subject using a 105 mm and 24 inches away using the 200 mm lens. This is particularly important when photographing outdoors in nature, when breathing or body heat can directly affect the subject. The razor sharp 60 mm

Figure 7.16

lens is excellent for copy stand work or studio work, but when outdoors a greater working distance is desirable; hence the 105 mm and 200 mm are the better choice.

Fish-eye 16 mm f/2.8D

This is a great specialty lens. We've all seen the funny, big face, fish-eye shots but when holding the fish-eye lens level, the bowing at the horizon is straight and makes an excellent wide-angle lens (with a little bowing at the edges). By using the lens in very small spaces, the fish-eye effect becomes almost unnoticeable and instead allows for a very wide-angle shot in situations inaccessible to longer lenses.

Tilt/Shift Lenses
24 mm f/3.5D ED, 45 mm f/2.8D ED, 85 mm f2.8D

A tilt/shift lens gives the photographer the ability to get sharp images with depth of field at minimal f/stops. This is done by

Figure 7.17

Figure 7.18

having a small knob that changes the axis of the lens; this in turn changes the angle at which the lens is relative to the subject. The more parallel the lens is to the subject area, the more open the f/stop can be to achieve deep depth of field.

What Lenses Do I Buy?

Obviously what lenses you ultimately choose to keep in your bag will be dictated by the type of shooting you plan to do, weight, convenience, and of course cost. If you're just starting out, a good wide-angle to telephoto zoom lens is a practical choice. This allows you to discover where your talent and passions lie prior to investing in the big glass. Good second-hand lenses always have good resale and trade value so it is relatively easy and painless to trade up when the time comes.

A photographer can pack a versatile kit with focal lengths that cover 14–340 mm in three lenses: 14–24 mm f/2.8 wide angle,

Figure 7.19

24–70 mm f/2.8 mid-range, 70–200 mm f/2.8 telephoto, and
adding a 1.7× tele-converter will take your 200 mm to 340 mm.
Add a 105 mm macro lens and you are ready for almost any
situation!

Flash Photography

Why Shoot With a Flash?

With the low light capability of today's cameras, I often hear many newcomers to the art of photography declare that they do not like using a flash; instead, they will just crank up the ISO on the camera. There are two problems with this approach. Firstly, removing the use of a flash from your arsenal sorely limits your creativity. Secondly, as good as the camera's low-light capability may be, there is always a trade-off. Higher ISO settings produce more digital noise in the image, and at high ISOs the accuracy of the camera's white balance system is compromised. Learning to use your flash, whether it is the built-in variety, or one of the Nikon Speedlites, will expand your capabilities and your enjoyment of the entire picture taking process.

Keeping It Natural

The real art to flash photography is learning to adjust the camera and the flash to the situation. Good flash photography actually belies the use of an additional lighting source. The subject will look natural without the telltale harsh look an improperly used flash will produce. You must learn to boost or enhance the existing light situation with your flash rather than try to supplant it. Figure 8.3 shows how the use of

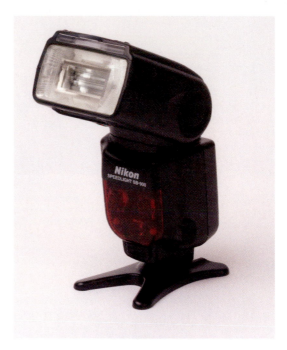

Figure 8.2

fill flash in an outdoor situation results in a natural and evenly lit face without the shadows that would normally occur outdoors in the sun.

Flash metering systems for the early digital SLR cameras were based on the TTL (through the lens) systems of film cameras, and proved to be inaccurate a great deal of the time. I well remember taking three to four shots of the same subject, with the same setting, and with different results. The flash output was based on the main object in focus with little, if any, regard given to the total composition. With auto focus systems, this would really wreak havoc if the photographer locked focus and then recomposed. With Nikon's innovative i-TTL system even an amateur can quickly learn how to get professional results using a flash.

Nikon's Creative Lighting System

Nikon's research and attention to this area of the market has paid off in a large way for both the amateur and the professional

Figure 8.3

photographer alike. The Creative Lighting System was designed to eliminate many of the problems traditionally inherent in flash photography. This is one of those cases where Nikon truly listened to the professional photographer and designed an outstanding state-of-the-art system for flash photography.

i-TTL Balanced Fill Flash

A pre-flash is emitted from the Speedlite prior to the main flash and reflected off every object in the frame. Either the five-segment TTL flash sensor or an RGB sensor picks up the information from these pre-flashes. This information, along with data from the Matrix Metering System, is analyzed to adjust flash output for the most balanced background/foreground exposure possible. This technology takes Nikon's flash control system to unprecedented levels of precision and performance. The addition of distance information delivered by many Nikon lenses combines to deliver a wealth of information to the flash system, delivering unprecedented accuracy.

Flash Color Information Communication

Getting proper white balance with flash photography has always been an issue as the color temperature varies with the type of ambient light, and mixing this with flash color temperature was a complicated process. Thanks to Nikon's Creative Lighting System, color accuracy is now better than ever. Using voltage, flash duration and other variables such as ambient light color temperature, the master unit attached to the Nikon Digital I SLR cameras transmits flash color information to the camera. This allows the Auto White Balance system to achieve optimum results.

Multi-Area AF Assist Illuminator

In all Nikon cameras compatible with Nikon's Creative Lighting System, the Multi-Area AF Assist Illuminator can be used with all the focus areas of the camera. This allows auto focus shooting in extreme low light situations, regardless of which focus area you select.

Flash Value Lock

The FV Lock (Flash Value Lock) maintains the same flash exposure for your main subject when shooting a sequence of photos, allowing you to zoom in on your subject, change the composition or adjust the aperture, all without changing the original exposure. This allows the photographer to focus on the subject rather than the mechanics of the Speedlite.

Auto FP High Speed Sync

This feature enables stop-action shutter speeds with fill flash. The camera will automatically set itself to this mode if your selected shutter speed is above the camera's top flash sync speed. This is indispensable for outdoor portraiture as it allows the use of narrower aperture settings to achieve the desired focus on the subject. For a sports photographer it allows flash photography and the use of stop-action shutter speeds.

Advanced Wireless Lighting

The Nikon Creative Lighting System supports Advanced Wireless Lighting. This allows the user to utilize up to four i-TTL Speedlite groups controlled via a master unit, which can be an SB-900 or SB-800 Speedlite, or a Wireless Speedlite Commander SU-800. The Advanced Wireless Lighting system is as easy to use

as an on-camera Speedlite. There is no limit to the number of Speedlites in each group, giving you almost complete control over how you light the subject.

Using the Built-in Flash

If your camera has a built-in flash, you can often use it as a great fill flash tool both indoors and out. You will often find, particularly with outdoor portraiture, that there is plenty of ambient light for a shot but also lots of harsh shadowing, especially in the facial area. In such situations, the built-in flash, judiciously used, can deliver more professional results. For outdoor shots, you may have to manually turn the flash on by pressing the flash button. Otherwise, the camera's metering system may sense there is enough light and fail to automatically engage the flash. You can also use your camera's flash exposure compensation function to vary the output by plus or minus

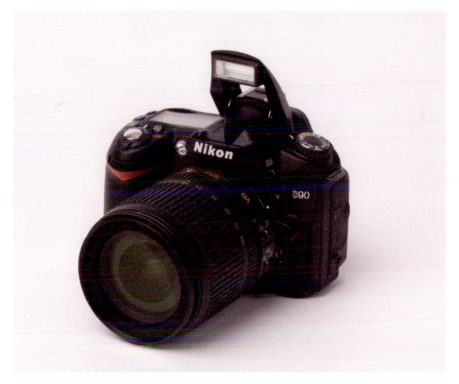

Figure 8.4

three stops, in increments of 1/3 stop. By adjusting the output depending on the lighting situation and the subject matter, you can make your images much more natural in appearance.

There are several downsides to using the camera's built-in flash. The proximity of the flash to the lens increases the tendency to produce hard light and red eye. In addition, the harsher, more pronounced light produced by the smaller flash units tends to give your images a flat look; your images look more like everyone else's snapshots. Vertical shots using the built-in flash are near impossible as the proximity to the lens causes huge shadowing. For flash photography beyond the occasional snapshot and fill flash situation consider one of the Nikon Speedlites.

Nikon Speedlites

Your two main choices in the Speedlite department are the SB-600 and the SB-900. Price aside, the one you choose should be based on intended use, both current and future. Study the features and specifications of each unit and decide if you need (or will need) more power, a flash head with zoom capability, remote control of other flash units, or if you just plan to use your flash for family pictures and the occasional portrait.

SB-600

The Nikon SB-600 is a compact, portable i-TTL Speedlite optimized for use with Nikon's Creative Lighting System. The SB-600 can be operated as a wireless remote unit by the SB-800 or SB-900. The SB-600 is ideal for the vast majority of shooting situations, and also makes a great second, or back-up, flash for the working professional.

SB-900

The SB-900 is considered Nikon's flagship Creative Lighting System Speedlite. It can be operated as a stand-alone unit or as a wireless command or receiver unit. As a wireless command unit, the SB-900 can control up to four other flash groups. The SB-900's auto zoom capability provides coverage from 17 to 200 mm in the FX-format and 12 to 200 mm coverage in the DX-format, and automatic switching from one DX to FX format.

Figure 8.5

Figure 8.6

With certain Nikon Digital SLR cameras, the SB-900 also automatically identifies mounted color gel filters and adjusts the camera's auto white balance setting.

One of the big new selling points for this Speedlite is its firmware upgrade capability. This allows the user to download and update the SB-900 with any new performance enhancements released by Nikon.

R1C1 Wireless Close-Up Speedlite System

Although arguably not a necessity for most photographers, this unit certainly merits a mention. If you take the leap into close-up or macro photography, this type of setup is indispensable. The R1C1 is a creative delight. It delivers the ability to easily and evenly illuminate many types of difficult subject matter, including micro, macro, and product photography.

The R1C1 is basically a true miniature macro studio. As in traditional portraiture, one of the flashes can be set at full power and the second one at -1 to create a modeling look for macro subjects. Fill flash can be achieved using a setting of 1:1 ratio and -1.7 flash exposure. Using TTL, aperture priority and matrix metering all work quite well. Any issues with exposure can be adjusted by setting the exposure compensation dial or by adjusting the flash exposure.

One of the great advantages of the R1C1 is the ability to remove one or both of the flashes and hand hold for precise placement.

Flash Photography With a Speedlite

Whatever Speedlite you end up with, there are some basic guidelines that will apply to the use of it.

• **Bouncing the Flash**: Often shooting head on with a Speedlite will produce a hard light and harsh shadows. An easy solution is to 'bounce' the light off the ceiling or the wall by titling the flash head up, to the side, or both (see Figure 8.7). This bouncing of the light serves to diffuse the harshness of the light as well as spread the light over a large area. Pumping light in behind the subject reduces or eliminates the harsh shadows that result from shooting with the flash in the standard position.

Figure 8.7

- **Flash Exposure Compensation**: One of the great advantages of the digital SLR is the ability to immediately see results and make appropriate adjustments. If you see that your settings are delivering too much or too little light, it is easy to adjust the flash compensation in 1/3 stop increments, plus or minus, until you have it dialed in.
- **Shooting Mode**: While shooting in Program mode will usually deliver a technically correct exposure, the Program mode naturally opts for a narrow aperture—with a shallow depth of field being the result. For that reason, we choose to shoot in manual mode. There is a learning curve, but the payoff is worth it. Choosing your own aperture and depth of field pays huge dividends creatively. Usually shutter speeds of 1/30, 1/60, and 1/125 will deliver good results in most situations. The longer

the shutter speed, the more ambient light captured. Many photographers consider f/8 to be a magic aperture in that it provides enough depth of field to garner the entire subject but not so much as to detract from it.

The secret is to practice and experiment. Take the time to learn about the interaction of shutter speed, aperture, and the flash. Your ability as a photographer will take a giant leap forward.

George Schoeber

'NIKON…I have always suspected that the translation in Japanese must mean or stand for 'brand loyalty' as most Nikon photographers have a long and very loyal devotion to their equipment and the legendary company that produces these fine photographic instruments.

Figure 8.8

My personal history with Nikon started in 1970 when I purchased (and still have) a black Nikon Photomic FTN with a 55 mm F1.2 lens. The Nikon F was the body that most professional 35 mm photographers used at that time for their work.

The Nikon F was lovingly referred to as 'the hockey puck' due to its incredible durability and reliability.

The Nikon F had a vast selection of accessories that Nikon produced to keep professional photographers happy with any assignment they could imagine. Nikons traveled in space with NASA, hung from the rafters at sports arenas and produced most of the memorable journalistic images of the 1960s and 1970s. But the real strength behind the photographers who used the Nikon system was the Nikkor lenses.

From 1959, when the first Nikkor SLR lenses were produced, to the 40 plus million that have been manufactured since, Nikon shooters have had a near reverence for their favorite Nikkor lenses. They became our photographic eyes that allowed us to express and create our individual vision.

Through the almost 50 years of Nikkor lens production and lens technology that has given us multi-coatings, floating rear elements, zoom lenses, Auto Focus, Vibration Reduction, ED glass, Nano Coatings and other advances, the Nikon F lens mount allows virtually every lens Nikon ever made (sometimes with a slight modification) to fit every Nikon professional camera ever made, including the most recent digital models.

My modern lens selection includes the 17–35 mm f /2.8, the 70–200 mm f/2.8, the 80–400 mm VR, the 17–55 mm DX f/2.8, the 12–24 mm DX f/4 and the 18–200 DX VR. A few of my favorite 'old' lenses include the 55 mm 3.5 micro, the 28 mm f/2.0 and my all-time favorite, the 105 mm f/2.5. The 105 mm is still my lens of choice for portrait work.

While Nikkor lenses have always received most of the accolades from Nikon shooters, the professional camera bodies have been the perfect complement to the great Nikkor optics. I have used the F, F3, F4, and my favorite film cameras of all time, the fabulous F5, and the possibly even better, the F100. The Nikon F100 is considered by many to be the best film camera

Figure 8.9

Nikon ever built. I always carried two F100s with me on all my photographic travels; it was durable, ergonomically perfect and the matrix metering is incredibly accurate.

I continued to shoot film up until the release of the Nikon D200. The D200 was the digital camera that reminded me the most of my beloved F100 and I purchased one as soon as they became available. The transition from film to digital was seamless and easy. Within 30 minutes of familiarization with the new camera, I was shooting images easily and quickly.

I was amazed at how easy Nikon had made it for photographers familiar with their professional film cameras to enter digital imaging. The D200 convinced me that digital capture was going to be my future in photography. I had set up a digital darkroom 2 years prior to my purchase of the D200, to scan transparencies and negatives to produce digital files and output prints. The

Figure 8.10

D200 showed me that by shooting high-quality RAW camera files, I could use this as either my color transparency or convert it to a B&W file if I decided to take the image in that direction. While aesthetically I loved film, and still do, the many benefits of digital capture won me over as a photographer.

I have since added the wonderful Nikon D300, and most recently the awesome D700 full-frame camera. The files from both of these cameras are truly amazing. Resolution and detail in prints of 48 inches, and even larger, are superb.

I find that the DX and the FX sensor sizes give me the options of using the wide-angle FX format or the far-reaching DX telephoto advantage. My compact 80–400VR lens becomes a 120–600 mm lens when used on the D300 camera.

The D700 with its very high ISO capability allows me to shoot in low light conditions that were previously taboo. Both the D300

Figure 8.11

and D700 are small, low profile cameras that can easily be carried together during travel or hiking.

While Nikon took their time in delivering a full-frame sensor DSLR, they seem to have made the wait for the Nikon faithful worthwhile. The cameras broaden the options that Nikon shooters have come to expect from the company that has always delivered the most comprehensive photographic systems and integrated lens compatibility in the history of camera manufacturing.'

Getting Your Best Shot from the Digital Negative

Overview

There are numerous editing programs available for adjusting and processing files from your digital SLR camera. Preferences are based on such variables as user interface, ease of use, and, of course, image quality. Most of the software out there does a good job, but at some point you have to make a decision to use a specific program and move ahead. Most programs can be downloaded as a trial, which gives you a chance to 'try before you buy.' This is a great policy and we encourage you to take advantage of it. In this chapter we will focus on Nikon's proprietary editing program, Capture NX 2, but we will also discuss a few of the other popular programs as well.

Nikon Capture NX 2

Nikon Capture NX 2 is the newest version of Nikon's proprietary software for processing Nikon RAW (NEF) files. Even if you plan to make adjustments later or print from another image editing program, using Capture NX will assure you get the best output possible from your RAW (NEF) files. Although Capture NX

2 was designed for Nikon RAW (NEF) files, you can also use it to process TIFF and JPEG files.

Version NX 2 brings important upgrades to Capture, including major improvements and revisions to the interface and workflow in addition to some important new editing tools.

The Browser

The primary purpose of the browser is to provide a convenient interface for viewing and editing files. By first examining image thumbnails in your browser, you can quickly choose the keepers and toss out the rejects. This avoids the laborious process of opening large files in order to sort them. There are various tools available to help in the process such as the Label, Rating, Filter, and Sort tools.

Double-clicking on a thumbnail in the browser automatically opens the image in the Capture NX editor. You can also open

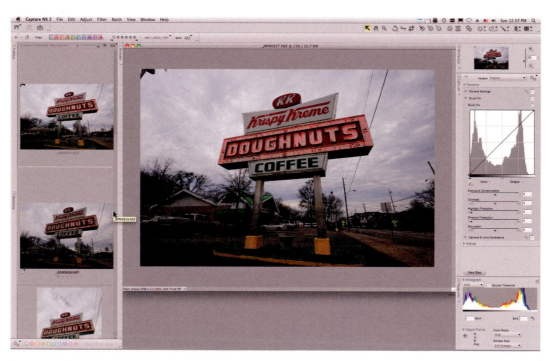

Figure 9.2

an image as you would in any other image editor: by dragging and dropping an image into the application, by using the Open dialog box, and so forth.

Non-Destructive Editing

Capture NX 2 is a non-destructive file editor, meaning any adjustments or changes are stored as a separate set of instructions rather than applied to the original file. This holds true with NEF, TIFF, and JPEG files. This is the same approach used by Adobe Photoshop Camera Raw, Lightroom, Aperture, and others.

The huge advantage of non-destructive editing is the ability to change or remove your edits at any time. If you've worked with Adjustment Layers in Photoshop, you understand the value of non-destructive editing.

Whenever one of the Capture NX 2's editing tools is used or an editing tool is chosen from the menu, a new entry is made in the Edit List, one of the main palettes that sit on the right side of the screen. In this Edit List you can adjust an edit's parameters, delete the edit, temporarily hide it, and change the order in which edits are applied.

The Edit List in NX 2 has been greatly improved. With NX 2, the Edit List simply lists controls that you can adjust. There's no extra sub-menu to deal with, which streamlines editing and allows more control of the Edit List. The Edit List is now divided into two major areas: Develop and Adjust. Develop is where you perform all of the basic adjustments to globally tone- and color-correct an image. Adjust is for additional, refined edits. Capture NX 2 automatically puts the edit in the appropriate pane within the Edit List.

Global Editing

Tone and color adjustments are controlled via sliders and buttons in the Edit Menu. New to NX 2 are Highlight Protection and Shadow Protection, which work similar to the Shadows/Highlights tool in Photoshop. Capture NX 2 identifies these regions as shadow or highlight areas and darkens or lightens only those areas.

As with the previous version, Capture NX offers highlight recovery for RAW files. Working with RAW files, it's possible

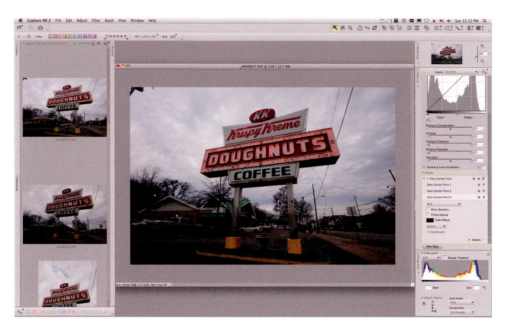

Figure 9.3

Figure 9.4

Figure 9.5

to recover overexposed highlights, restoring image detail to blown-out areas of an image. This should be a standard feature in any good RAW conversion program as it is essential for the photographer shooting RAW format.

Selective Editing

Capture NX's already excellent localized editing tools are now even better. Actually, Capture NX 2's biggest strength is its selective editing capability. Using the control points found in Capture NX 2, you can easily create precise multiple selections and masks that can be individually adjusted. This is a much easier process than it is in Photoshop. Using a control point is as simple as clicking it on the adjustment area of the image and using the sliders to adjust brightness, contrast, and saturation. You can even adjust the size or radius of the adjustment area. The color is sampled beneath the area of the control point, and this information, along with the radius area of the control point,

is used to calculate the scope of the adjustments. Using color in addition to the selected radius area keeps the adjustments extremely well localized.

Batch Processing

Any edits can be copied and applied to any number of images in the group. This is particularly handy when you have a large number of images shot under the same parameters. You can literally copy and paste any edits, including selective edits, from any image to another or to a whole folder of images. This dramatically speeds up the workflow process.

Even if you are not planning to shoot in the RAW format, and you primarily work in JPEG mode, Capture NX 2 is a good alternative to some of the other stock editing programs out there. Most Nikon cameras come with a 30 day trial, or you can download trial versions from the Nikon web site. It is certainly worth a look on your part as Capture NX 2 is a powerful editor for processing NEF RAW or JPEG files.

Other Considerations

There are several other popular image editors out there and in our opinion any one of them will deliver professional quality results when properly used. Workflow has become more and more of an issue with the digital age. Unlike the film days, many photographers today finish a wedding with anywhere from 800 to 2000 images that they have to process themselves! Consequently, good results with minimal time investment have become foremost in the minds of many. It usually comes down to what you are comfortable using and which image editor delivers the desired results with the least hassle.

Adobe Camera Raw

One of the first, and consequently more popular, digital image editors is Adobe Camera Raw, which is built in to Adobe Photoshop and now Adobe Photoshop Elements. If you already own one of these programs and you are familiar with the operation of it, it's certainly tempting to stick with what you know.

The Camera Raw user interface is intuitive but, more importantly, keyboard shortcuts, editing tools, and the menus all behave in

Figure 9.6

the familiar Photoshop fashion so anyone already familiar with Adobe's programs will easily acclimate to Camera Raw. Cropping and resizing, and adjustments to exposure, contrast, saturation, and white balance are easily accomplished with the intuitive toolbar.

Batch editing is a simple matter as well. You can control or command click on multiple images, make adjustments to one, and have the adjustments applied to all selected images. This is particularly handy when setting white balance and exposure to large numbers of studio shots with the same lighting. You can even save a set of adjustments and load them later to apply to a different image or set of images.

Adobe Lightroom

Although the Camera Raw engine is the same, Lightroom offers many features above and beyond what's found in Photoshop's

Figure 9.7

Camera Raw. Many photographers have flocked to Lightroom as a sort of 'one-stop-shopping' application. In addition to the non-destructive editing and processing of digital files, Lightroom is engineered with storage and archiving in mind. Images from your Library can be stored in Collections. With the use of Keyword Tags, management of large digital archives can be a simple task. If you commit to learning and using the Lightroom system you will be able to locate any image in your archive quickly.

Other great features include the convenience of browsing images in a slideshow format and the ability to export slideshows. Output options include print and web layout, with automatic gallery creation and upload capability.

For those who do not have Photoshop and shy from the steep price or the learning curve, Lightroom is a great solution for archiving and taking your files all the way from the camera to print and/or web.

Figure 9.8

Figure 9.9

Figure 9.10

Aperture

Apple's entry in the digital editing arena was widely anticipated, but the first version proved to be a bit less than many photographers had hoped for. Version 2, however, has proved to be an excellent program for managing and editing digital files. Like Lightroom, many photographers find an attraction to editing, archiving, and managing output from one source program. As with Lightroom, the ability to add keywords to an image, and save each work session as a separate project, definitely speeds the digital workflow process. Aperture also makes global or batch-style editing an easy process. Aperture's interface is both intuitive and user friendly making it an all-round good choice for any photographer with a Macintosh computer (no Windows version at the time of writing).

In Conclusion

For the sake of a good solid workflow (and your sanity) we recommend finding and sticking with an image editor that

Figure 9.11

is easy to use, and that suits your needs as a photographer. Constantly changing to a new image editor, because you hear it's the latest and the greatest, becomes tiresome, counterproductive, and it cuts into time you could be out there shooting great images.

Peter B. Kaplan

Peter B. Kaplan was born in Manhattan, NYC and raised in Great Neck, Long Island. He has lived in New York City, NY, and Chilmark, Martha's Vineyard, MA and at present resides in Hockessin, Delaware. He still maintains a studio in New York City where he resided for over 30 years. After his military obligation, he continued his college education majoring in photography at Sam Houston State in Huntsville, TX. He assisted many of New York's top commercial photographers and, because of his avid interest in nature and wildlife photography, studied under Ansel Adams, Bob Sisson and Doug Faulkner.

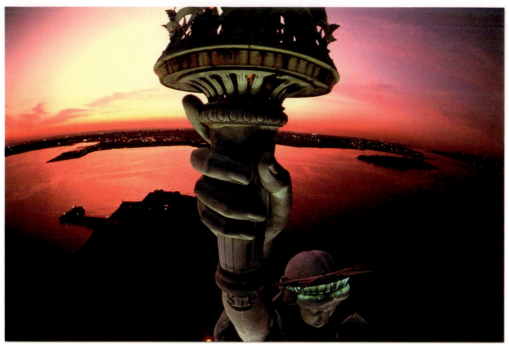

Figure 9.12

His interest started to shift to architecture upon completion of the World Trade Center in 1974 when his specialty of 'Height Photography' was born. Mr. Kaplan's photographs have been placed in time capsules under the Empire State Building for its 50th Anniversary and the Brooklyn Bridge for its 100th Anniversary, and also in the spire of the Chrysler Building during its 50th Anniversary Restoration. He was awarded the title of the 'Preferred Photographer' of the Statue of Liberty/Ellis Island Foundation, Inc. where he was a volunteer for 10 years, starting in 1982 when they began the restoration for the 100th Anniversaries of these two world renowned monuments. He has created over 125,000 images, while painstakingly documenting every aspect of the Statue of Liberty's historic restoration. To date, he has the most extensive and complete story on the Statue. These photographs were used to raise over $500 million for the restoration of these two national monuments.

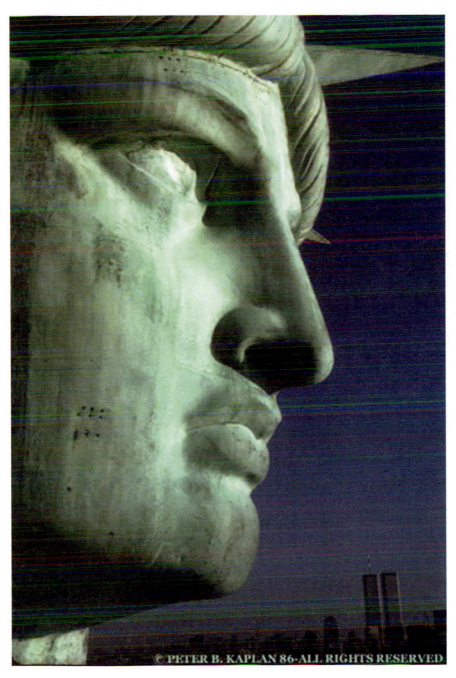

Figure 9.13

He has been featured numerous times on the *Today Show, Good Morning America, Sunday Morning with Charles Karult, P.M. Magazine, Cable News Network* and *Real People* just to name a few. He has appeared as a spokesperson for Eastman Kodak, Nimslo 3D Camera, Soligar Lens and Nikon Cameras. His photographs have appeared in almost every major magazine in the world and have hung in shows at the Canton Art Institute, Ohio; Cooper-Hewitt Museum, NYC, Municipal Arts Society of New York City, New York Historical Society, NYC; N.Y. State Museum, Albany: Nikon House, NYC; Museum of Modern Art, NYC; Smithsonian, Washington DC and International Center for Photography, NYC; to name a few.

He was honored when the United States and French Governments selected his image for the Statue of Liberty 100th Anniversary Commemorative Stamp issued July 4, 1986. His images were also selected to appear on 170 different commemorative stamps in 13 other nations.

Harry N. Abrams published his first book, *High on New York*. 'These unusual pictures combine the skill of a professional photographer, the perception of a fine painter and the daring of a trapeze artist,' said Paul Goldberger, Architectural critic for *The New York Times*. His Statue of Liberty photos were used exclusively in two books published for the centennial of *The Statue: A Celebration of Freedom and Liberty, The Statue* and *The American Dream* published by the National Geographic Society.

In May 1987, the Friends of the Golden Gate Bridge appointed Mr. Kaplan the 'Official Photographer' for the 50th Anniversary Celebration of the Golden Gate Bridge. Eastman Kodak created a limited edition of dye transfer prints from this assignment and presented these to various dignitaries.

In 1990 he was sponsored by Eastman Kodak to produce a one-man show called *Three Coasts*, which was on display for over a year, at the Museum in the St. Louis Arch for their 25th Anniversary. In the summer of 1991, the 'Operation Welcome Home, NYC' committee named him the official photographer for the parade. In 1992, he created the advertising photos for the World's Fair in Seville, Spain. The following year he created advertising photos for the German Bundapost. Both of these images were created from cranes with his signature 16 mm fish-eye overview.

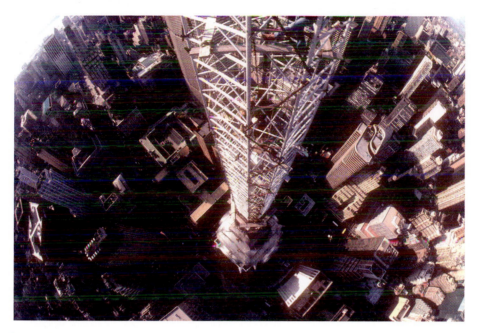

Figure 9.14

In 1985, he married Sharon Rosenbush in a ceremony held on the 96th story ledge of the Empire State Building. Their wedding bands were created from scrap copper of the new torch of the Statue of Liberty. They have a daughter, Ricki Liberty, and a son, Gabriel Liberty. In 1995, Mr. Kaplan moved his corporate headquarters to Hockessin, Delaware, where at present he resides with his family. Since moving to Delaware, he has had several one-man shows and in 1997 he was awarded a State Fellowship and an NEA grant to work on his newest Statue of Liberty book, released in December 2002, called *Liberty for All* written with his co-author Lee Iaoccoa.

In the spring of 1998, the US Postal Service released the Art Deco Commemorative Stamp in the Century series using Mr. Kaplan's Chrysler Building image. In November 1998, he did the first pull-out cover for the 90th Anniversary issue of *Philadelphia Magazine*, along with an eight-page essay inside showing his height and special technique called 'Pole Shots' of Philadelphia. In 2002 he had more images selected than any

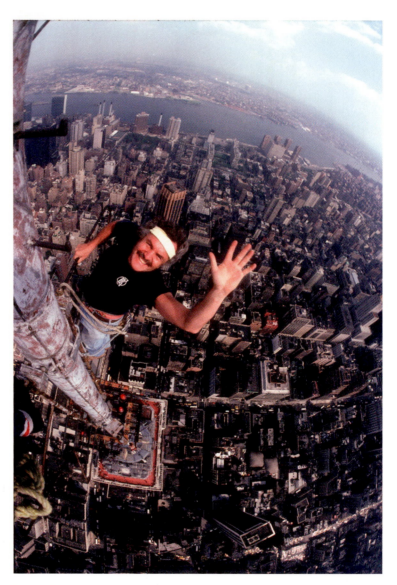

Figure 9.15

other photographer to use in the one-year commemorative book of 9/11 published by Rizzoli called *Eleven*. In 2003, his work was selected to be used in *America 24/7*. In 2004, as well as having many images selected for inside use, his image was used as the cover of the *Delaware—America* 24/7 state book.

INDEX